SACRED ART OF TIBET

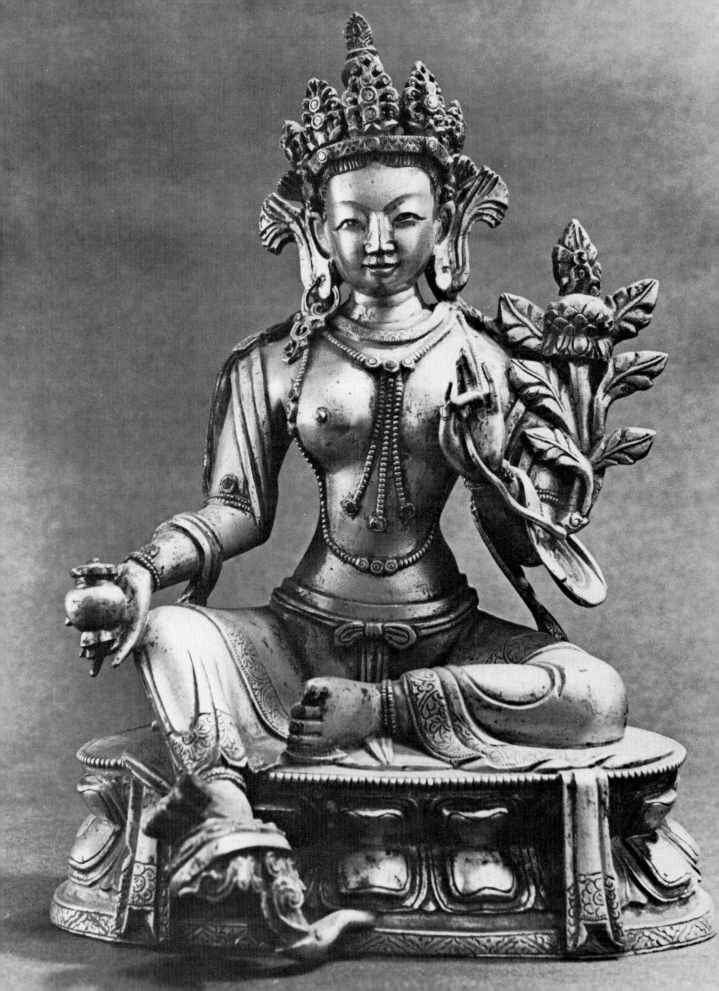

SACRED ART OF TIBET

Tarthang Tulku

Introduction by Herbert V. Guenther

DHARMA PUBLISHING

*First issued on the occasion of
the Sacred Art of Tibet Exhibition
and Film Festival at Lone Mountain College,
San Francisco, December 1972.*

*Reissued for the Sacred Art of Tibet
exhibitions at the Berkeley Arts Center, March 1974,
and at Grace Cathedral, San Francisco, June–July 1974.*

*ISBN 0-913546-00-3
Library of Congress Catalog Card Number 72-96555*

*Layout, composition and printing by Dharma Press
Printed in the United States of America*

Cover: MAHĀKĀLA, *the protector and guardian of the Buddha's
teachings, subdues illusion and transforms negative energy.*

Frontispiece: *The Great Bodhisattva* TĀRĀ *(Drol-ma), one of the special
protectors of the Tibetan people. Revered as the "Mother of All Beings," the
compassionate savioress Tārā rescues those who invoke her aid from the eight
great dangers.*

Foreword

I am very happy to have this opportunity to share the tradition of sacred art in Tibet with so many people. This exhibition is the result of great efforts on the part of many friends who work with me, and I very much appreciate all their help. Two years ago we had a similar exhibition which was very successful. Once again I am glad that so many people can view these very sacred images, which still preserve something of the vanished religious culture of Tibet. In their homeland these images were considered very meaningful and powerful, and we believe that there is great blessing in just receiving them visually. It gives me a wonderful feeling to think of these sacred images going everywhere in people's minds and hearts.

The specific details of these images are very complex and of interest primarily to students of esoteric Buddhist practices. Unfortunately, very few people today can even explain their meaning. Generally, the details portrayed on the images of Tibetan Buddhist art have symbolical meaning related to the study of the human consciousness; mostly they correspond to various specific meditations, visualizations, and other advanced practices. We have attempted to explain this further in our introduction.

Although we were too limited in time and funds to undertake a more comprehensive catalogue, eventually we hope to publish a catalogue that will include color prints as well as more detailed explanations. We strongly believe that the Tibetan tradition, where religion, art, and culture are closely bound together, has much to say to people suffering in the present age. May this exhibition, humble as it is, bring benefit to the lives of sentient beings.

Tarthang Tulku, Rinpoche
Head Lama, Tibetan Nyingma Meditation Center

Acknowledgements

This collection of Tibetan art is an outcome of the Sacred Art of Tibet exhibitions held December 1972 and January 1973 at Lone Mountain College. Now we are reissuing this catalogue for our 1974 exhibitions. As always, this exhibition is the collective effort of many people who are united by their generosity and openness in helping us preserve the Tibetan culture. Through the associations we made with private collectors for the earlier Sacred Art of Tibet exhibitions, and in the generosity of many new collectors and museums, we have again assembled a unique collection of Tibetan Buddhist sculptures and paintings. Without their kindness, trust, and willingness to participate, these showings would not have been possible.

Encouragement and assistance for this catalogue came from many sources. We are expecially grateful to Valrae Reynolds, Newark Museum; Bennet Bronson, Field Museum of Natural History; James Cahill, University of California Art Museum; David Roach, American Society of the Eastern Arts; Teresa Tse Bartholomew, Center for Asian Art and Culture; and Alex Nicoloff, Lowie Museum of Anthropology, for their advice and assistance. We wish to acknowledge the contributions of Fred Stross and Charles Oliver, who donated their photographic services.

The Development of Tibetan Art

The beginnings as well as the unfolding of Tibetan art are inextricably interwoven with the history and geography of Tibet. History here is to be understood in the narrower sense of dated history. Tibetan historical records trace back to the time of King Srong-btsan-sgam-po (died in 650), when Tibet shared and even began to influence the destiny of its neighboring Asian nations.

Geographically Tibet was surrounded by countries having high levels of civilization. To the north lay a string of small oasis states whose inhabitants spoke an Indo-European language and whose religion was Buddhism. Among these oasis states Kucha upheld the Hīnayāna tradition, while Khotan adopted the Mahāyāna form of Buddhism. Khotan became the center for disseminating the Avataṁsaka teaching, which later became the basis for the Hua-yen and Kegon schools in China and Japan respectively. Between 666 and 692, and again from 790 to 842, these Central Asian oasis states were part of the Tibetan empire. Cultural links with Tibet endured until the Uighur Turks settled in these areas in the middle of the ninth century.

To the west lay Ta-zig which roughly refers to Persia. Often linked or interchanged with Krom/Phrom (the east Iranian Hrōm or Frōm), which seems to have referred to Byzantium and later to the Seljuks of Anatolia, Ta-zig may have inspired the form of the recumbent lions with human or animal heads carved on the end beams under the entrance portico to the Jokhang temple in Lhasa. Such figures are well-known in Persian folklore. There were other countries as well in this part of Asia: Gilgit (Bru-sha in Tibetan), which has preserved the Midas theme that the Bonpos incorporated into their ancestry, and Kashmir, where Rin-chen-bzang-po (958–1055) was sent to study the

Dharma. On his return he was active as a translator and founded several temples in Guge (Gu-ge)—Toling (mTho-lding), and, in all possibility, Tabo and Nako in Spiti (sPi-ti). To the west and south lay the ancient land of Gandhāra with its Graeco-Roman (Hellenistic) art form. Uḍḍiyāna, home of Padmasambhava, who is also linked with the country of Zahor, is sometimes located in northwestern India, sometimes in Bengal.

In the east was China which, at the time of the ancient Tibetan monarchy, was acquiring a new dynasty, the T'ang (618–906). Artistically, the T'ang would soon display an incomparable vigor, realism, and dignity. Intellectually, however, it tended towards intolerance and formalism, which may have contributed to Tibet's looking more towards India for inspiration, although separated from India by formidable mountain ranges.

Nepal, then developing its own civilization, lay to the south. Further south in the Indian subcontinent, two centers were of particular importance for the Tibetans: the kingdom of Kanauj on the upper Ganges region in northwestern India under King Harṣa, who promoted Buddhism, and Bengal, where Buddhist tantric ideas prevailed at a time when the Pāla kings had to pay tribute to Tibet.

Since no culture develops in a vacuum, it is only natural that the art of Tibet reflects many traits that derive from the neighboring civilizations. It also is an historical fact that Buddhist art took root in Tibet when Tibet was politically ascendant and culturally receptive. And while it is correct to say that Tibetan art was "influenced" by the art-forms and styles that prevailed in the countries around Tibet, it would be a mistake to understand "influence" as mere "imitation." Rather, influence acted as a powerful stimulus. The rich material that flowed into Tibet was not received passively. It became the foundation and playground of creative activity.

The bKa'-thang-sde-lnga (a text concealed in the 8th century and rediscovered in 1347) has preserved the awareness of the Tibetans incorporating the art forms and styles developed by their neighbors. It records that, when the Samye (bSam-yas) temple was built, the lower part was done in the Tibetan manner, while the middle part was roofed in the Chinese style and the upper part in the Indian style. The same work also states that a castle to the southeast of Samye, built by King Mu-khri-btsan-po, was Tibetan in its ground floor, Khotanese in its two-roofed first floor, Chinese in its second floor, and Indian in its third floor.

This description is somewhat incomplete. It remains a problem how a Chinese roof could be built without walls or pillars, and be topped by an Indian roof. All that seems certain is that there were buildings that combined a purely Tibetan architecture with Chinese and Indian roof-styles. The fact that the Indian roofing is said to top the Chinese one appears to emphasize the importance of India's contributions. We know that King

2

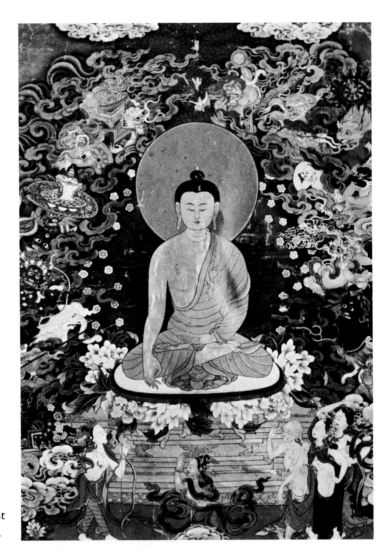

ŚĀKYAMUNI BUDDHA

At the moment of
supreme realization.
His left hand is held
in the dhyāna (meditation)
mudrā. With his right hand
he calls the earth to witness
his dedication to selfless
action, and renders powerless
the terrifying forces of Māra,
Lord of Illusion, which swirl
around him. Having overcome
Māra, Śākyamuni attains the most
complete, perfect enlightenment.

Ral-pa-can (Khri-gtsug-lde-btsan) who reigned from 815–838 and signed a peace treaty with China in 821–2, invited skilled craftsmen from India, China, Nepal, Kashmir, and Khotan. The king, particularly impressed by the Khotanese craftsmen, demanded their services at the threat of invading Khotan. The Khotanese style, which features bird's-eye views of architectural groupings and uses fine, wavy moustaches in portraiture, influenced Tibetan art well into the 15th century.

In the years that followed, distinctive artistic styles developed in each of Tibet's major regions. In western Tibet, painting and sculpture flowered in the 11th and 12th centuries, when the kings of Guge, in particular, patronized the fine arts. Due to its geographical position, western Tibet reflects the style of painting developed in Kashmir, which in turn was influenced by the art that flourished in eastern and central India

3

during the Gupta (ca. 300–600) and Pāla dynasties (ca. 730–1200). The last phase of this western Tibetan style, found in Spiti, Guge, and Purang (sPu-rang), is connected with the monasteries and temples of Tsaparang (16th–17th centuries).

Gyantse (rGyal-rtse) in southern Tibet became an important artistic center during the 14th and 15th centuries. Since this southern style absorbed the Nepalese traditions which incorporated elements of Pāla art, it became known as Beri (Bal-ris), or "Nepalese style." According to 'Jam-mgon Kong-sprul (1813–1899), the Beri style was the mainstream of Tibetan painting up to the 15th century. Eastern Tibet also gave rise to distinctive styles and rich artistic traditions, cultivated at Derge (sDe-dge) and the surrounding areas. In the first half of the 15th century, sMan-bla Don-grub of sMan-thang in Lho-brag founded the Menri (sMan-bris) school, which incorporated Chinese elements

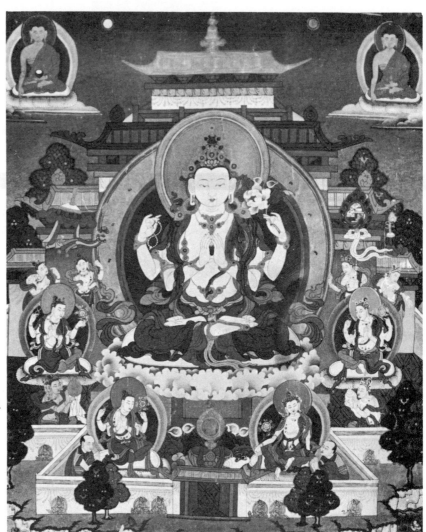

1 AVALOKITEŚVARA

The Bodhisattva of Infinite Compassion. He holds in his hands the indestructible jewel, the lotus, and prayer beads.

4

of the Yüan period, including designs and techniques used in elegant embroideries and tapestries.

The following century saw the rise of the Khyenlug (mKhyen-lugs) school, based on the painting style of mKhyen-brtse'i-chen-mo. This style also makes use of Chinese elements in the representation of depth, the treatment of backgrounds, and the attention to detail. In the 17th century, it merged with the "New Menri" (sMan-bris-gsar-ma) school, which is attributed to Chos-dbyings-rgya-mtsho, who flourished between 1620 and 1665. A blend of Khyenlug, Gadri, and late Indian styles, the New Menri tradition continues in the Lhasa or central Tibetan style (dBus-bris) of the 20th century.

Out of the classical Menri school came the Gadri (sGar-bris) school, inspired by the work of Nam-mkha'-bkra-shis of Yar-stod (second half of the 16th century). The main features of this school were a light use of colors and shading, and innovations in the treatment of backgrounds and compositions. A related school known as Karma Gadri (Karma-sgar-bris) shows the greatest Chinese influence in its use of realistic landscape elements such as rocky cliffs and subtly drawn trees and flowers.

This account, of course, traces only the main currents of Tibetan artistic styles. There were lesser schools, mostly derivative from the major styles and remaining more or less "provincial." In spite of this proliferation of schools, Tibetan art has not become fragmentary: artistic styles were always subordinate to the content. This is due to the fact that Tibetan art was, and still is, basically a visionary art. It is inseparable from the philosophical background of Mahāyāna Buddhism with its emphasis on spiritual growth that becomes accessible to understanding through symbols.

The complexity of Mahāyāna Buddhism is revealed in the Sūtras, which present its intellectual superstructure, and in the Tantras, which explicate the existential foundation and the growth of humanity toward true being and appreciative awareness. The existential character of Mahāyāna Buddhism as a dynamic process is technically known as Vajrayāna—vajra being a symbol of the indestructible nature of Being, and yāna the path that develops understanding of the meaning of Being.

Thus, Tibetan art is representative of the Vajrayāna in particular. A visionary expression, it assists in bringing the things of this world into perpective, rather than subordinating or reducing them to fictitious schemata or mere postulates. "Existential" in the sense of communicating values and meanings that are intrinsic to Being and not arbitrarily assigned, the beauty of Tibetan art is not so much a quality, or characterizing particularity by which something is distinguished from and contrasted with something else; rather, as the "manifestation" of Being, it evokes, in manifesting itself, something that increases the charm and the value of Being and lets the beholder appreciate it.

Introduction to Tibetan Sacred Art

To appreciate Tibetan art we must appreciate ourselves, the fact of our being, our quality of awareness and all that is manifested therein. Tibetan art is a part of this miraculous process of manifestation, not a comment on it or an attempt at an entertaining alternative to it. If we fully understand this art, then we are aware of being Buddhas in a Buddhafield. If we fully understand ourselves, then we are aware of being Buddhas in a Buddhafield.

In each case, then, and in all cases, what is constantly being "made manifest" is—Buddhahood. Can you see it? Can you be tricked into looking for it? There is no deceit intended by—or confusion involved in—the two assertions that: "All beings are already Buddhas." "All beings must strive to transcend their state of delusion and to become Buddhas." But if these statements only inspire confusion and uncertainty, then one may instead confidently follow the path to Buddhahood illumined by Vajrayāna art.

The Ground of Śūnyatā

The Sambhogakāya, of which this art is one aspect, bridges the distance between many apparently contradictory statements, between different levels of awareness and forms of existence, between the ultimate and the conventional. A very unique bridge, it *links* but does not *separate*. It manifests an essential connection without thereby individuating things or asserting that there exist things whose differences stand in need of

reconciliation. The Sambhogakāya is not some subtle medium in which all entities are suspended. Rather, it is the *entities themselves* standing open and fully revealing themselves to an awareness that is aware of its and their "śūnya" character.

Śūnyatā is an impish challenge to man's insistent desire to reify, to conceptualize, to classify, to discriminate. It refuses to give him an excuse to be lost in a sleep of fascination or limited awareness. It deprives him of any basis for his most gripping passions and his driving fears. Man's ego is alarmed by such a merciless foe, and declares its alarm to be a justifiable "fear of the void." But śūnyatā is not something in the first place, some-

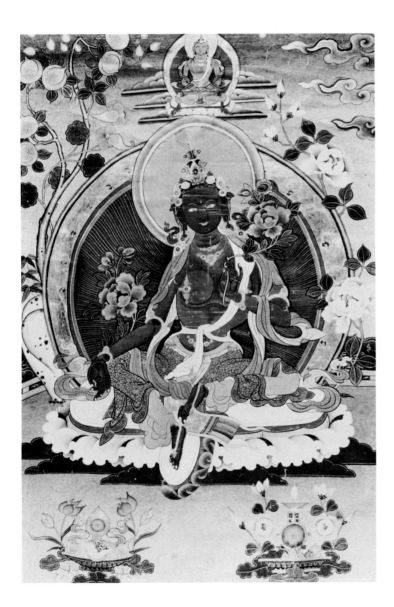

2 GREEN TĀRĀ

A Sambhogakāya emanation of the Buddha Amitābha, the compassionate savioress Green Tārā is one of the Great Bodhisattvas, highly venerated in Tibet.

thing that can be mistaken for something else, for a "void." It is nothing—nothing to possess specific properties, nothing to be possessed, nothing to understand or to achieve. Its greatest impudence consists in telling man that he is nothing too.

In doing this, the śūnyatā doctrine is not to be taken as an insult to man, or a sinister attempt to impoverish him or his world. This doctrine points out that man's self, his mind and the objects of his attention are all expressions of a field of limitlessly rich possibilities. Assertions that certain things exist, or that they possess a unique and independent self or essence that makes them exclusively what they are asserted to be, are only part of a selection and stipulation process. This process involves a specification of one type of awareness (rather than others), and of the type and extent of the world that one is to be aware of. If one realizes this, the world that is apparent is also manifestly the "ultimate" reality—there is no hidden or unactualized potentiality. If one does not, then the "world" is a trap in the very midst of paradise.

Unfortunately, verbal explanations are usually not enough for one to *realize* this. But Tibetan art, as an expression of the Sambhogakāya, does not need to *tell* one anything—it *demonstrates*. The śūnyatā doctrine urges man not to concretize his world into a container of solid, brittle "things." The Sambhogakāya is totally fluid and mutable. Śūnyatā warns us to choose freedom rather than traps. Unencumbered and unfettered, the Sambhogakāya is at play. If all boundaries and distances are śūnya, then it would seem that unity is available to us, that we need not accept an imposed "separateness."

The Sambhogakāya's compassionate action may comfort us in our isolation, revealing the fulfillment of connectedness and unity. Śūnyatā denies the need for "doing" and "achieving," and the existence of an independent "doer" who can be benefited. Without "doing" or changing anything, the Sambhogakāya's light reveals the sameness of the ultimate and the ordinary—its light *is* this "sameness." The logic of śūnyatā exposes the relativity of such concepts as "space" and "time." With direct experience of the Sambhogakāya, one transcends these relativities.

Although we have been emphasizing the Sambhogakāya as *showing* what the doctrine of śūnyatā implies, śūnyatā can and must be experienced directly, and is itself the basis of the Sambhogakāya's action. If we wish to distinguish them, we may say that śūnyatā and the Sambhogakāya are mutually complementary. Even a little understanding of one will render the other more accessible to us, which in turn will deepen our understanding of the former.

Vajrayāna Tantric Art

The foregoing discussion is fundamental to the methods, purpose and nature of Vajrayāna thanka art. The art and its associated practices were consciously developed according to these two insights, and literally embody both of them without distorting their significance. Tibetan art is therefore not merely a prelude or preliminary to meditation on the Sambhogakāya or śūnyatā. Form and color may express the "emptiness" of śūnyatā, and may do so at least as well as some insipid blank. A painted scroll, properly understood, need not "tone down" or hamper the endlessly pervasive expression of the Sambhogakāya. Instead of extrapolating beyond the given, of searching behind and beyond appearance for the ineffable, one would do well to just look—even at a thanka. This is a good place to begin, even if it is true that there remains much to be discovered.

As an initial example of the influence of the Sambhogakāya and of śūnyatā in and on thanka art, we may consider the art's representational style. The element of space is used to suggest a total openness of possibility as to what may happen, and where. Light either lacks any specific source—coming from everywhere—or emanates from a thanka's central figures in such a way that their existence and their qualitites are naturally revealed in their light, and are revealed wherever this light extends throughout the infinite space they dwell in. These figures or beings emerge, as it were, from nowhere, from anywhere. They appear to lack foundation or origin. They consequently appear to lack any restrictions on what they may become or what they may accomplish. What transformations may they not undergo? What transformations may they not effect in us? Mutable in form and free in their scope of action, their radiant presences communicate to us by awakening us to the realization that we too are free in a field of open possibilities. "Your awareness may also be expressed in endless forms in endless worlds," they say.

It must here be pointed out that the technique of seeing the world as phantasmagorical or apparitional is quite distinct from seeing it as empty of restrictions on being, knowing and compassionate intercession. The former can be an effective means of disentangling one's self from a world created by delusive projections. The latter, however, discovers in the world of appearance the source and actualization of all meaning and value. It is not a technique or lesson of any kind, and has no goal beyond itself—it is purely fulfillment. Remarkably enough, it is open to us to adopt this enlightened vision, to use it to bring our lives into focus. This focus destroys the double-vision which makes our goal and our path appear separate. We are freed to take all paths as invitations to an effortless and all-accomplishing non-doing. As we employ the Buddha's vision, we perfect it.

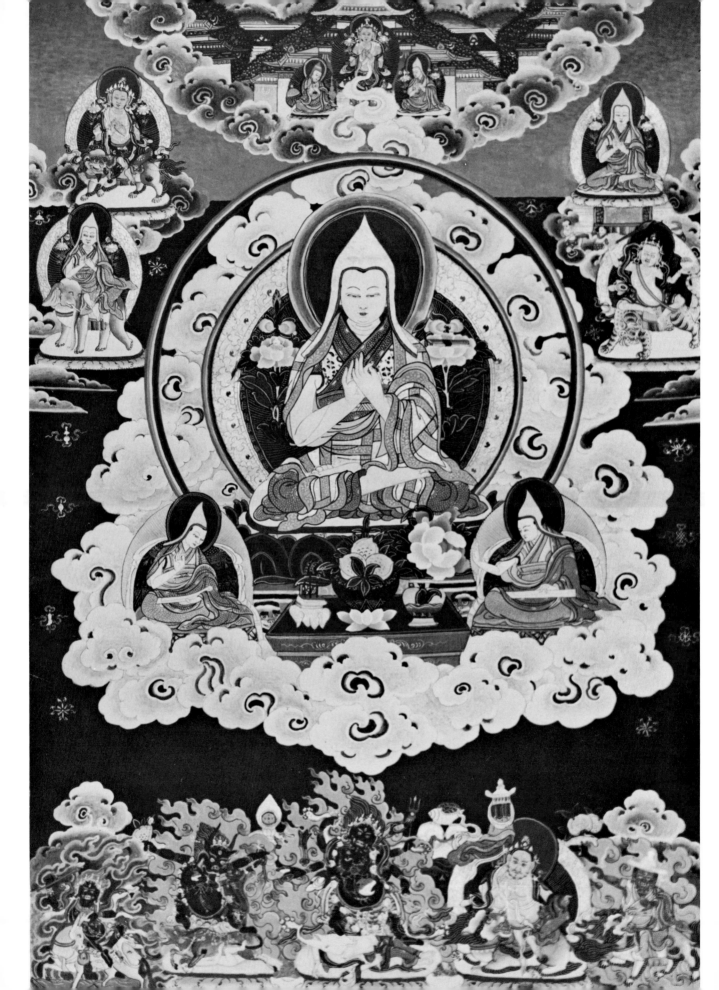

Explorations into the avenues revealed by this mutability of form and freedom of expression are not games or escapes for a neurotic mind. The extent of our realization of this freedom and of our ability to utilize this mutability corresponds exactly to the degree of our selflessness and our compassion. Complete freedom comes only with the maturation of an enlightened attitude into the omniscience of Buddhahood. Both before and after the dawn of this awakening, our freedom may only be meaningfully used in communicating itself to others. In this way, the light of the Sambhogakāya may also stir others in their turn to awaken.

Such themes of thanka art as the mutability of form may be mistaken or misused in many ways. Even if we understand and act in accordance with its true meaning, we may easily fall prey to a subtle attachment to it. Rather than taking it as merely one step towards Buddhahood, as one example of what thanka art offers, we may take it as the standard for all that we find in the art. But the Sambhogakāya does not span all the distances we create, and thwart our best attempts at clinging to egoistic responses, merely to lead us to a long-term infatuation with some realization—even a genuine one. Nor does thanka art exist merely to serve up some "truth" to us in a quaint or colorful manner. In preference to *this* attitude, it might almost be better to maintain that the art does not exist for any *purpose* at all, and that it recommends the same course to us. It advises us to give up childish pretend-games of "being-in-order-to," and to learn to just *be*. These cautionary remarks should be applied to whatever we subsequently say about what Vajrayāna art is or does.

3 TSONGKHAPA
20th Century, Dharamsala

Tsongkhapa (Tsong-kha-pa) is in the center with his two greatest disciples, Kedrub Je (mKhas-grub-rje, right) and Gyaltsab Je (rGyal-tshab-rje, left). Tsongkhapa is an emanation of Mañjughoṣa, depicted above the central figure. On Mañjughoṣa's left is Atīsa, founder of the Kadampa (bKa'-gdams-pa) school; to Mañjughoṣa's right is Tsongkhapa, who continued Atīsa's lineages and incorporated them into the "new Kadampa" school. Clockwise from the top are Tsongkhapa enthroned, the great siddha Ḍombhipāda, Dorje Shugdan, Vaiśravaṇa, Mahākāla, Vamarāja, Palden Lhamo, Tsongkhapa on an elephant, and Mañjughoṣa. The thanka is new and painted in the Mongolian style.

Beauty as a Manifestation of the Ultimate

Man has at his disposal two ambassadors who help him negotiate the subtle entrance through Tibetan art into the Sambhogakāya realm. One is beauty, and the other is a cultivated mindfulness of śūnyatā. The art's beauty spurs us to action, and inspires us to seek the highest goals we know of at a given time. Śūnyatā tempers our approach, forestalling our crude rush towards ethereal goals. It reminds us of the emptiness of self, subject, object and "achieving." It further points out that beauty is also "empty," and that if it is objectified into something that may be possessed, it will be lost. Beauty is only that particular aspect of appearance that we readily accept as a manifestation of the ultimate in our world. Having once been aroused by it, we should learn to extend our awe and reverence to all aspects of appearance as being equally expressive of an ultimate reality. When we have learned to do this, then we truly awaken to beauty, to the sort of beauty that is the Vajrayāna's specific concern. We also awaken to a much deeper understanding of śūnyatā. Śūnyatā is far more than a device or doctrine for regulating our behavior. The beauty that first attracts us and the śūnyatā that cautions our initial efforts towards spirituality are not the highest beauty, the ultimate śūnyatā. Only with this in mind may we correctly interpret the statement: "If we understand the right way to look, everything is seen as beauty." The "beauty" referred to here is not that which beckons and entices. The right way of seeing is not merely a stubborn determination to like everything, or to overlook things which threaten to appear as negations.

The Nature of the Deities in Tibetan Art

As an essentially religious art, Vajrayāna art must in some way be concerned with such notions as "the unsatisfactoriness of worldly existence" and "salvation." Now it is a commonly observed fact that man, when confronted by the need to choose between these two states, is often given to clownishly extreme antics. He tries to forcibly seize and cling to some "salvation" and, failing that, totally surrenders himself to a blind faith that a certain savior or doctrine will somehow carry him through. To some degree or other, many people follow this pattern. Our discussion of the Vajrayāna and its art may suggest some reasons why the Vajrayāna does not lend itself to such crude treatment, and why, on the other hand, it may harmlessly accommodate it. Tibetan art supplies the devotee with objects which, considered in the light of the śūnyatā doctrine, may be "taken" without thereby augmenting the ego's greed, and with deities to whom (as Sambhogakāya manifestations) one may give one's self without creating an unhealthy

dependence. In this case, any over-enthusiasm on the devotee's part does not result in an exhaustion or degradation of either him or of the deity involved. One is not expected to fixate on—or slavishly surrender to—these deities. But regardless of one's initial stance, the subtlety of understanding and depth of experience expressed in these images and their attendant practices will sustain one through a vast range of discoveries.

The curse of man's ordinary mind is his engagement in the activity of warping reality into a polarized subject-object field. Most "objects" of such an awareness only perpetuate this condition. Thanka art, however, supplies us with "objects" which actually heal this separation. At first we will necessarily view them as objects, but as our meditation progresses we may well reverse positions, according them the status of "subject." Eventually we cannot help but give up such fictional posturings altogether. Since it should be obvious how the doctrine of śūnyatā, with its denial of any absolute basis for boundaries, "essence-difference," or relative positions is influential in our dropping this duality, we may now concentrate more exclusively on the significance of the deities in thanka art. These deities will help us surprise and unmask that nimble contortionist who delights in a solo playing of the "knower," "knowing" and the "known." The śūnyatā doctrine warns us that he and his drama are not what they seem to be, and thanka art reveals the full import of this warning.

The Practice of Visualization

In the beginning of our efforts at meditation, however, we cannot be quite so concerned with revelations. The problem of dealing with the lazy, dull and vicious qualities of our immature minds presents itself as being in much more immediate need of consideration and treatment. As the first of its many ministrations on our behalf, meditation or visualization involving Vajrayāna art both points out the full extent of this problem and supplies us with the proper remedy. Grasping, ignorance and tightness are most clearly exposed when contrasted with unlimited openness, knowing and compassion. The shabbiness of a way of life characterized by the former qualities is starkly pinpointed in the light of one replete with the latter. On the other hand, the only way to forsake the one way of life and take up the other is *to begin*, and to begin on the level from which all qualities derive—the level of the mind.

The Vajrayāna therefore places great emphasis on the practice of visualization, of mentally embracing and eventually realizing a oneness with the deities introduced to us

by thanka art. A precise correspondence exists between the forms, colors and postures of these deities and the types of awareness which they are considered to manifest. Our bodies are the embodiments of our characteristic human consciousness, and so too are Vajrayāna deities the embodiments in sensible forms of "divine" awareness. Both this quality of "divinity" and its corresponding forms are quite accessible to us—by entertaining and perfecting these forms in our own consciousness, we may actualize the awareness and virtues which these deities present to us. It is in this sense that we *become* them, and it is by implementing this "becoming" that the deities first speak to us in the Sambhogakāya fashion. At a certain point in this process of self-perfection, however, we may become worthy recipients of the transcendent revelation that we already *are* the deities, that there has never been a time even in our most black or vicious moods when the deities and their qualities were not fully actualized by us and fully exemplified by our every thought and act. This is the ultimate realization offered by Vajrayāna practice, and the ultimate sense in which the Sambhogakāya communicates to us. The Sambhogakāya awakens us to what first appears as the *path* to perfection, but what is actually our complete and ever-abiding perfection itself.

Since we are preoccupied with unsatisfactoriness, we welcome the Sambhogakāya as a remedy. Since we are involved in doing and appropriating, we eagerly respond to the Sambhogakāya as being a call to "great" doing and appropriating. It is really neither of these. Visualization practice does not, therefore, merely involve putting a new mask over our old ego — we *are* changed and perfected by it, until we are tempered and strong enough to make the great leap to the realization that all such notions as "changing," "remaining unchanged," "virtue" and "vice" are "empty." Like momentary spots before our eyes, they should not tempt us to abandon the beauty of our lives in order to pursue

4 CELESTIAL BEING
Thanka detail

A deva returns to the celestial realm carrying Prince Gautama's
freshly cut hair, a relic of the future Buddha's resolve to
renounce worldly pleasures and liberate all beings from sorrow.

14

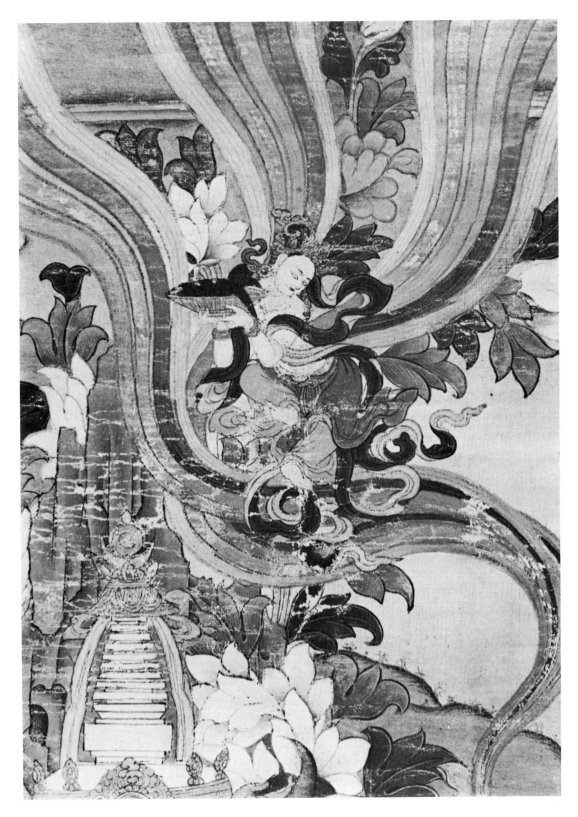

or avoid them. Thanka deities reside fully at ease and in harmony with their world—their *presence* is their "doing."

We exist in a world of causes and effects. It is therefore inevitable that our initial interchange with the Sambhogakāya influence follow this same format. The relation between the visually perceived characteristics of a given deity and the quality of awareness that is at first nurtured by meditation on these characteristics is a "causal" one, in about the same sense that any thoughts are said to "cause" other thoughts or to mold personalities and world-views. On this level of visualization practice, a kind of psychological science is at work. However, the final and transcendent realization is eternally uncaused, and reveals that types of awareness, their associated manifestations and these manifestations' evocative power all have śūnyatā as the ultimate source and basis of their relationship. These general remarks should make several things clear. The incredible numbers and variety of deities in Tibetan art do not make up a "religious pantheon" (as this term is ordinarily understood), and do not derive from a desire to invent a complex imaginary world for us to lose ourselves in.

It is often somewhat heatedly asked: "Well just what is the status of such deities?" In reply, we may first point out that these deities are *here for us.* Since we exist, they become manifest. Since we exist *as we do,* they become manifest *as they do.* Our state of confusion and misery makes necessary and inevitable (since they are aspects of ourselves) their appearance as revealing what we persist in overlooking. It is, perhaps, silly to question the status of such "divine messengers" and at the same time to naively accept the dreary and confining status that man appears to have. If we are stubborn enough to enact only a tiny part of our true potential and to accept only a section of the much larger field available to us, then we should not be surprised if the "exalted reminders" are equally stubborn in thrusting themselves upon our condition.

Thanka deities, then, do not exist independently of us and our qualities. The deities are relevant to us in such a way that, while they do not indulge our old games and habits, neither do they lead us on a course which ignores the "facts of life." They are neither inventions for fun nor vehicles for escape. They do not *need* to be invented; they are a direct and uncontrived response to our condition.

Do thanka deities "exist?" What is their ontological status? In reply to these questions, perhaps it should be asked: "What is the ontological status of a *way of being?*" For, Vajrayāna deities embody *ways of being*, not *things.* Nor are these ways merely potential, awaiting instantiation in the world—they are already fully active. Vajrayāna visualiza-

tion practice does not involve a three-term relation between an individual, a tantric deity and some thing which this deity and this meditation are instrumental in helping the individual become. Visualization does not involve a relation between *things* at all.

We are accustomed to thinking in terms of a fixed picture according to which some "things exist." The Vajrayāna is not interested in adding some new things to the list of existents; rather, it urges us to give up our preoccupation with "things" altogether, and to also either give up this picture or to realize that it is—just a picture. Buddhist tantric deities are admittedly not "things" that are limited to "existing" in a so-called objective world, but then, neither are human beings. Without any break, interruption or hardening into isolated things, awareness opens unto awareness, spanning all the possible realms of experience. To visualize is to consciously dwell in this continuum. Tantric deities exist, therefore, in a way that it is also important for human beings to exist in. They are known by the same means and in the same manner that we know ourselves *as human beings*. In fact, knowing them may help us to know ourselves in this manner. Speaking pragmatically, we may say that their utility consists in guiding us until we reach the realization that *they* are not tools and that *we* have no ends that need to be furthered. Thus we learn to respect both them and ourselves.

The Ultimate Nature of the Deities

Although responding to our situation and appearing in forms that encourage our access to them, the forms and actions of Vajrayāna deities are also equally governed by these deities' participation in ultimate reality. They are glorious and awesome, therefore, not merely in contrast and as a remedy to man's inglorious and dismal predicament, but because ultimate reality *is* glorious and they are not separate from it.

It is often said that thanka art points to a "hidden reality." This reality is hidden to ordinary human vision, but is still not divorced from our human nature. Vajrayāna visualization practice teaches us to see it by first seeing the art with our mind's eye, then through all our other senses, then with our energy center (cakras) and finally by taking every element of our being and our world as *seeing*. What once was hidden then becomes clearly revealed.

We cannot see the whole of reality by exerting just a part of ourselves, but only by summoning everything that we are. This suggests the kind of involvement that we must bring to the deities and worlds of thanka art. It is not sufficient that we relate to them

merely as being responses to a part of our total situation, and as cut off from their relation to ultimacy. If we are willing to give them all of our attention, and to allow them as vast a range of significance as is their due, then we may fully experience the enrichment afforded by this art. Since we are usually determined to devalue appearance, to find its value as being above or behind it rather than in it, we tend to interpret thanka deities as pointing beyond themselves. In reality, they only point beyond our initial comprehension of them.

5 AMITĀYUS YAB-YUM

Amitāyus is the Sambhogakāya reflex
of the Buddha Amitābha (seated above).
Amitāyus is visualized in this form
as part of the sādhana, or religious
practice, associated with him.

18

Thanka art and its deities are effective, but what do they effect? They interact with us and for us, but what do we need? In meditating upon the deities and upon our identity with them, we are not trying to become, to restructure or to change anything. Thanka deities are not showing us something to be—our nature is that of śūnyatā, not that of a *substance* which can be molded, added to or subtracted from. Furthermore, suggestions that these deities show us what we *are* only trigger more inappropriate responses—"Oh, am I really the same as these divine beings? How nice!" Divine inspiration must of necessity be very subtle. It must guide us to perfection without encouraging us to fall into more "doing;" it must lead us to appreciate what we are without merely titillating our egos. Much of Vajrayāna practice therefore consists in very strenuous efforts that remain grounded in a "pre-view" of ultimate truth, in the assurance that nothing will or needs to really change.

Among the many things that we may believe about ourselves and our purposes, there are perhaps a few that are tentatively suitable for visualization practice. We begin with ideas about ourselves, the deity and our goal that have no validity and no other value than their capacity to rouse us to set to work. If we are fortunate, however, before we attain our initially cherished goal we will instead wake up to a new understanding of who we are. At this point, we will no longer *believe* ourselves to be anything. In fact, we will be quite sure that we are nothing (śūnya). At this point true Vajrayāna practice begins, and proceeds with our having no purposes or intentions, whilst engaging our energies and attention in such a manner that all our latent tendencies toward ignorance or imperfection fall away. We work until some part of us "knows." Then we dwell in this insight and allow our continued action and attention to purify themselves until we are "all-knowing."

It is the special quality of the deities' power and character that enables our attunement to them to accomplish such an effortless and unconcerned purification. The deities naturally appear in such a way that their appearance calms our inclination toward confusion, shows us the perfection of which this confusion is but an inversion, and simultaneously *is* the perfection itself. However, as soon as we outgrow the disposition to seek abstract realities which need to be illustrated or represented, and to isolate conditions which we feel need to be healed or transformed, we perceive the deities differently. Both they and we are understood as naturally self-sufficient. Again, any remaining vestige of delusion on our part immediately recasts the deity in its role as illustrator or healer, which it then plays very effectively. This process continues until there is nothing left in

us that needs to be convinced; further offers of revelations and assistance do not tempt us. The deities do not come here from some other world — they have always been with us. Anchored partly in our need and partly in our perfection, they are appropriate manifestations for either condition.

One practices the Vajrayāna with the intention that everyone will benefit from his labors. This intention is built into the practice in many ways, and is certainly fundamental to the idea and execution of visualization. The deities are visualized not just from the limited point of view of our ego and our position, but in such a way that they extend their promise of enlightenment to all sentient beings. We must learn to experience the deities as though everyone is simultaneously experiencing them with us. In this way, we are taking a step toward truly communicating with a deity in the Sambhogakāya fashion, where each "speaker" is expressing his participance in the totality of what is real.

A more elementary purpose to this, however, is simply to force the ego to relinquish its hold on perception, to "purify appearance." Of course appearance does not actually need to be purified or enriched, but we must still aspire to strike up a proper relationship with it. For most of us, appearance is obscured and laden with ego-projections. In such a state, our world, our body, and our perceptions cannot provide ego-transcending objects for our meditation; they must temporarily be replaced by an "expanded vision" of the worlds, deities and qualities of awareness depicted in thanka art. If we develop the power of meditation in order to obtain what we imagine we need and to perfect the persons we believe ourselves to be, we are imprisoning ourselves in our own delusions. Meditation is harmful in the absence of a correct point of departure. By relating to appearance from the point of view of a tutelary deity, we avoid further scribbling on a picture that's already overworked, and use our awareness to promote integration and harmony instead.

The worlds conveyed in thanka art offer us great freedom to explore, to rediscover the newness and open possibilities of our environment. At the same time, they provide us with a firm guidance that prevents our explorations from degenerating into egoistic flights of fancy. Thanka art's great science consists in the generation of elements which can only prompt one to develop that maturity. As long as we carry our limitations with us into the deity's realm, the brilliance and beauty of that realm will elude us. This art meets us at our own level and grows in significance precisely as we grow in penetrating clarity of mind. At various times it may offer us a play-pen in which we may experiment without hurting ourselves, a training ground in which we may perfect our awareness,

and a field of activity from which we carry out our intention to awaken all beings to en-lightenment. It thus sustains us through each of the three stages in our development toward Buddhahood.

The creative vision involved in this development is the liberating expression of the Sambhogakāya itself, not some grandiose production of the imaginative faculty which is the very source of our delusion. This is not to say that we play no part in the genera-tion of this vision — we must have a much greater involvement in it than we do in our fantasies. The meditator never forgets that the entire process of maturing to enlighten-ment begins, proceeds, and ends in śūnyatā.

Consecration by the Deities

Ancient texts on Buddhist art declare that the deities never enter forms other than those of the prescribed proportions, with their numerous designating marks. We may understand this to mean that religious depictions cannot introduce us to the Sambhogakāya action unless they are executed so as to correspond exactly to both ul-timate reality and to the specific way in which human beings must approach and grasp it. Every aspect of our existence may be restored to its proper significance and dignity through the agency of thanka art. When we therefore invite a particular deity to con-secrate us and our world, this being a request that he invest us with his qualities and ways of being, the art shows us what we should expect.

The deity's body is made exactly to the proportions and attitude that clearly con-vey to us his particular kind of awareness. Our own bodies are often experienced as limit-ing or acting in opposition to our minds, and as standing as a barrier to mutual understanding and recognition among us and our fellows. The deity's body is "all of a piece"—it is understood to be equally aware and "knowing" in each of its parts. Our bodies are conglomerates of specialized parts whose different functions tend to confuse and distract us. Whereas we are engaged in helter-skelter doing, the deity is in vibrant repose. For us, light is a precious gift from outside (above) us, and which we depend upon to reveal our location and status in an uncertain world. What is not alight is un-known and feared. The deity radiates his own light, which is uniquely expressive of his character and which illumines the entirety of his world, every direction being an unfold-ing of his own vast possibilities. (Very often, space only emphasizes our feeling of small-ness and inadequacy.) We are plagued by isolation from others and alienation from

ourselves. He, on the other hand, manifests his completeness in ecstatic embrace with his essential nature. Whereas we cling to objects, his consort in this embrace is śūnyatā. While we are even inclined to fix upon him as an object, his awareness is directed totally outwards from its śūnya-center, that all sentient beings may attain to this center. A thorough and minute correspondence obtains between us in our world and his being in his own. In this way, appearance may be reinstated to its primordial splendor.

Once we have developed some understanding of the deity's mode of being and its relevance to us, and have freed ourselves of some of our more constricting associations, we may extend the visualization to include our own bodies and perceptions. At this point, the work of stabilizing appearance in its essential sanctity may proceed quickly. Our emotions, our senses and their objects, our perceptual categories, space and time, all reveal their one-valueness, the ground for both Buddhahood and bondage. If the deity grants us his empowerment, we will experience it to extend through the present moment to every moment of our past and future, through all other beings and all their pasts and futures. The entire round of rebirth and causation will be laid bare to śūnyatā.

There is nothing that is changed by this great course. Appearance, our ordinary understanding of it and our common reactions to it are all the ultimate reality. And yet, we may need the art to see this. In fact, to learn to appreciate the full richness of appearance, we need an art that is comparably rich, one that does not exhaust itself in lame attempts to capture some aspect of appearance. Vajrayāna art is the very quintessence of appearance, where all appearance is understood to be a call to transcendence. We might say that there is no limit to the levels of philosophical and yogic meanings expressed in every detail of thanka art. But it must be emphasized that this art is not merely a container of such profound knowledge, and does not exist solely in order to convey it. The

6 GUHYASAMĀJA
18th Century, Central Tibet

Guhya refers to the representation of outer, inner, and
secret. Guhya is the Sanskrit word for secret or perfectly
internal. This is because the Anuttara Tantra class to which
this deity belongs is the secret or perfectly internal Tantra.
Vajrayāna Buddhism contains within itself practices which
do not necessitate changes in the outward form of the practi-
tioner. One who is accomplished in the perfectly internal
Tantras may seem on the outside to be no different from any
ordinary person, but on the inside he is a perfectly accomplished
yogi. Above Guhyasamāja is Trisong Detsan (Khri-srong-lde-btsan),
the 8th-century Dharma king who invited Padmasambhava to Tibet.
Below is the Dharmapāla Mahākāla.

knowledge is there because the art is not separate from the reality it brings to our attention . . . the art, the reality, are complete. Thanka art has many levels of significance because it is alive to the possibilities inherent in each of our moments and perceptions, and brings these possibilities to light for us. Significance is not "stored" in the art, nor are the art's elements only *stipulated* to possess it. If one tries to "retrieve" the art's meaning in the same manner that one fathoms a phrase by referring to a dictionary, only a mockery of the Vajrayāna's true import will result. If we are ready to live in our full potential, finding meaning in our every experience, the art may teach us a great deal.

The Significance of the Deities

Depending upon one's character, his level of maturity at the time of beginning the Vajrayāna path and the turns that his ego takes in fleeing the inevitable ascendancy of Buddhahood, one will find reason to invoke the aid of various particular deities. As our responses to meditation practice change, the qualities of different deities may be used to advantage in maintaining the balanced perspective upon which continued progress depends. Not all practice consists in ego-taming, however. It is quite possible for us to reach a plateau from which our time is better spent in exploring reality's deepest mysteries than in further beating worn-out ego structures. At this point too, there are specific deities who may assist our development.

Śākyamuni Buddha set in motion the Dharma wheel which unfailingly counteracts delusion by generating innumerable enlightened people and enlightening doctrines. Depictions of the Buddha help affirm our basic orientation throughout a many-sided course of development.

The Arhats exemplify the refinement of character which Śākyamuni stressed as the foundation for enlightenment.

As the models for all Bodhisattvas, Avalokiteśvara, Mañjuśrī and Vajrapāṇi exhibit limitless compassion, wisdom, resourcefulness and power in their selfless efforts to awaken all beings to Buddhahood.

Having attained to the supreme comprehension of reality, the Mahāsiddhas reveal reality's spontaneity and power in their every act. Their "siddhi" (often misleadingly translated as "power") consists in their having thoroughly experienced the ultimate in every aspect of appearance. They are blissful not because they have succumbed to

pleasure-seeking, but because the fullest expression of the ultimate in human being is "Great Bliss" (Mahāsukha).

Representations of Padmasambhava and the long lineage of gurus in Tibet who preserve his teaching direct our attention to the source of the Vajrayāna's energy on our level of existence. Since they taught and granted blessings directly from a state which transcends space and time, we may still approach and learn from them.

We are inspired to follow these lineage teachings to their conclusion by ḍākinīs who, as embodiments of an understanding of śūnyatā, are beautiful to behold but are entirely śūnya in nature. So must we understand all appearance to be beautiful, where beauty is an invitation to the full experience of śūnyatā.

Standing astride the corpses (portrayals of "deadening" influences) of the sleep-inducing attitude of eternalism and the "souring" doctrine of nihilism, the wrathful deities fling off all the limiting shackles of the ego. The ego is tight and small but they are free and unbridled—they trample and burn away even the most deeply entrenched remains of ignorance, lust and hatred. Their purpose is not to activate emotional ego-responses such as fear, but to *open* us. No Vajrayāna art derives its power or meaning from stirring up emotional impulses of any kind. Wrathful deities, therefore, are not creatures of vengeance who punish us for our wrong-doings. Neither does their disagreeable aspect indicate that they are our enemies.

Dhyāni Buddhas unravel what is for us the impenetrable mystery of the omniscient Buddhamind. They obligingly stand as separate Buddhawisdoms while we become attuned to them individually, until we finally effect their synthesis to regain the irreducible and pristine awareness of which they are the Sambhogakāya manifestations.

Tutelary deities maintain a most intimate relationship with us, fostering our development until that time when they bid us to draw near to them and to the knowledge that we and they share the same essential nature. They bequeath us the heritage of their own unsurpassable patterns of being and knowing, proving beyond question that we may realistically adopt them.

Mandalas of vast arrays of peaceful and wrathful tutelary deities, ḍākinīs and Dhyāni Buddhas, provided that we are given the key to their inner significance, put to rest our fears that our minds, perceptions, bodies and world are fragmented and bewildering. There are no "loose ends" that need to be retrieved or accounted for. A mandala places us squarely in the midst of a harmonious unfolding of all beings, Buddhas, and realms, from a center that loses track of nothing and explains everything.

25

The primordial Buddha Samantabhadra oversees this unfolding of myriad forms, beings, deities, conflicts and resolutions. Samantabhadra is unconcerned, even with the reflection that there has never been a departure from perfection, never an isolated sentient being or Buddha. "His" overview and unconcern with narrow views and pretenses are simply features of that experience of enlightenment which is open to everyone.

The Vajrayāna considers its art to be very sacred. Such terms as "sacred" sometimes elicit ridicule rather than reverence, since they are taken to designate objects which must, under pain of censure, be regarded with no attempt at critical evaluation and with strained piety. Vajrayāna art has great power to effect profound transformations in our level of consciousness, and in pointing to a "divine" realm it clearly indicates our own value and significance as human beings. It is therefore easy to respect this art, just as it is easy to respect ourselves, and deliberate attempts *not* to do so make no more sense than does masochism.

In what way does aesthetic appreciation differ from other sorts of appreciation? And what is "art," what is its purpose, which class of things are to be taken as art, and for what reasons is something to be taken as "good" art? Vajrayāna philosophy has very definite answers to these questions, at least for its own art. It also makes fully possible what for other aesthetic traditions remains an unrealized dream: The moment of appreciation, during which art's message and our own experience merge in the light of a deeply felt personal comprehension of a universal insight, may be infinitely extended by Vajrayāna practice. The art and the world of our experience inform and enrich each other until an all-inclusive continuum of understanding is established.

Tiring of abortive attempts to specify the exact extension of the class of "art" objects, some Western artists and aestheticians play with the notion of accepting everything as being "art." Unfortunately, they find it very difficult to do this in any nontrivial or interesting way. They have an equally hard time reconciling the belief that art should reveal "profound truth" with the assertion that in no case should we look beyond the "given," concerning ourselves with meta-perceptual ends. The Vajrayāna does not find these points to be quite so problematic. It teaches a very sophisticated technique which involves accepting all objects and perceptions as "art." And to anyone who has fully mastered the Vajrayāna path, nothing could be more obvious or more profound than the discovery that everything *is* art, and is art for no other reason than that everything is what it is . . . that is enough.

Catalogue
of
Plates

In these brief descriptions of the thankas and rūpas, we decided not to delve immediately into the more esoteric aspects of Tibetan art and religion. At the outset, long intellectual explanations tend to lessen the depth of intuitive understanding that color and form— devoid of rational categorization— can evoke.

A visual presentation of sacred subjects such as this allows the senses to experience the art directly. While explanations as to implements, attributes, symbologies, Tantras, colors and mandalas are important for a total appreciation of this art, the purpose of this catalogue is to introduce the basic principles of Tibetan sacred art, providing immediate aesthetic appreciation and opening an avenue for further study.

7 LORD BUDDHA
18th century, Central Tibet

Lord Buddha is represented in the "bestowing mudrā." Overhead
is the Panchen Rinpoche, probably Lozang Yeshe Palden, who lived
in the 18th century. Above the Buddha are great scholars of the
Gelugpa school of Tibetan Buddhism. Below him to the left is an
emanation of Mañjuśrī, manifestation of perfect wisdom. On the
right is an emanation of Samantabhadra, embodiment of perfect
activity. Directly below Lord Buddha is the world-protector
Vaiśravaṇa, accompanied by the flame-surrounded figure of
Vasanta Rājñī, a female Dharmapāla.

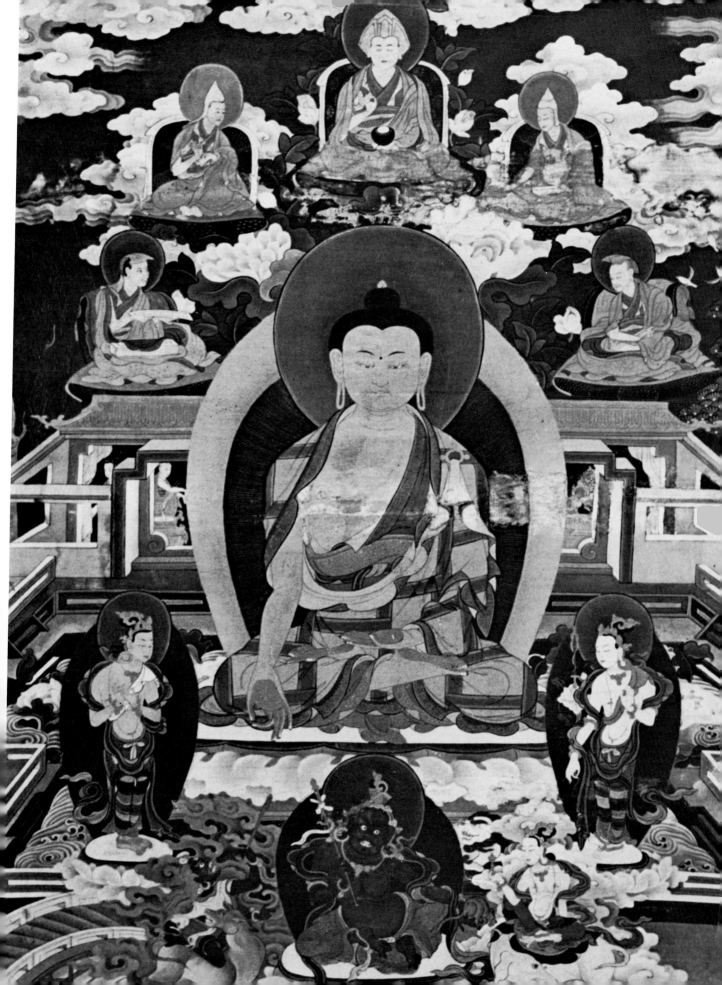

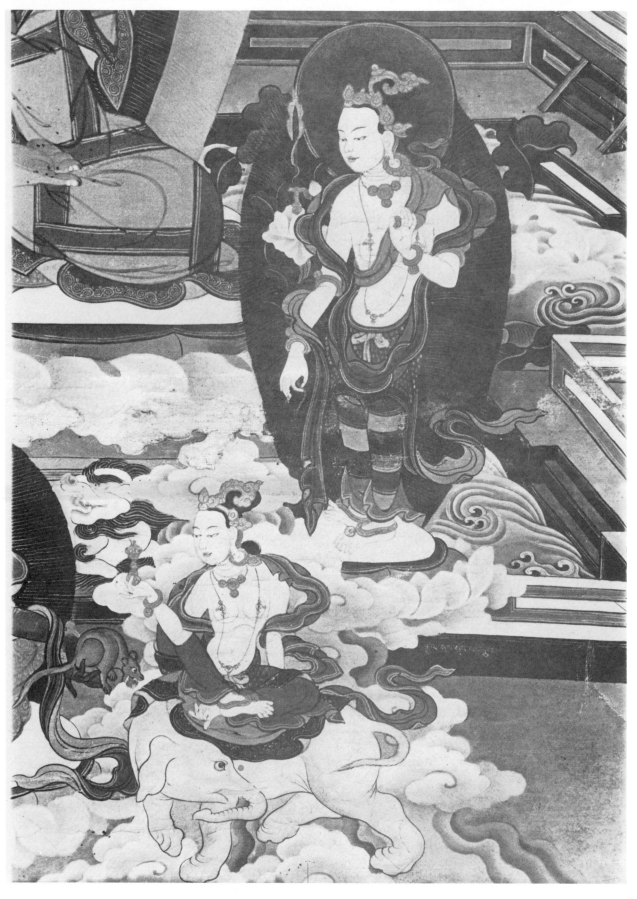

7a. Detail of the Bodhisattva Samantabhadra

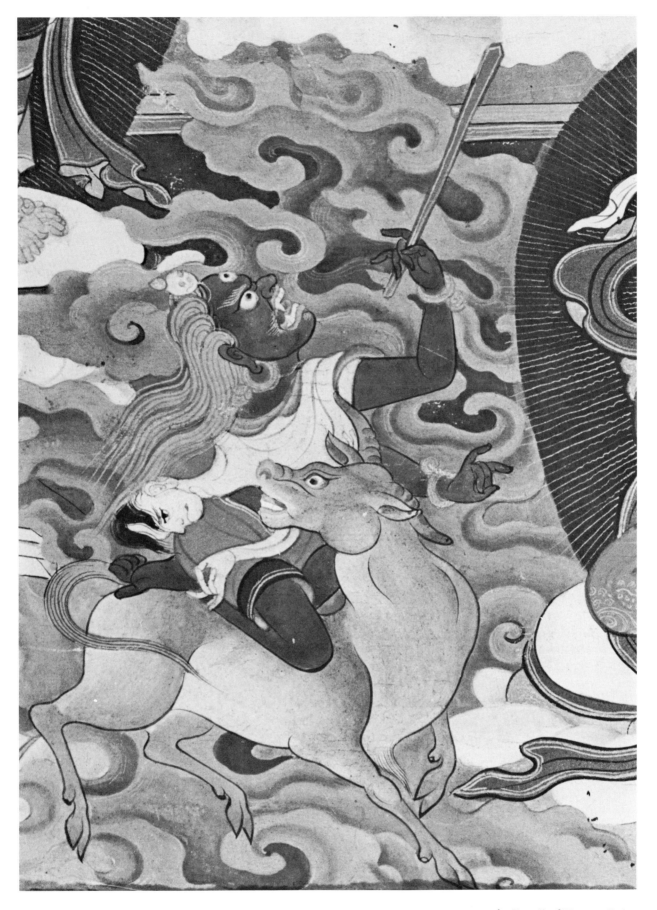

7b. Detail of Vasanta Rājñī

8 AMITĀYUS
18th century, Kham

Amitāyus, Buddha of Boundless Life, is closely associated with
the Dhyāni Buddha Amitābha. As heads of the Padma Buddha
family, they are the spiritual sources from which emanate
the compassionate Bodhisattvas Avalokiteśvara and Tārā.
Amitāyus resides in Sukhāvatī, the Western Paradise, where
those who invoke the blessings of Amitābha can be reborn.
Rebirth in Sukhāvatī, where conditions are perfect for
attaining enlightenment, is earned through merit and faith.

Here Amitāyus is portrayed in the jeweled splendor of
Sambhogakāya manifestations, holding in his hands a vase of
amṛta, elixir of immortality. Surrounding him are 108 smaller
manifestations, seated in the same posture.

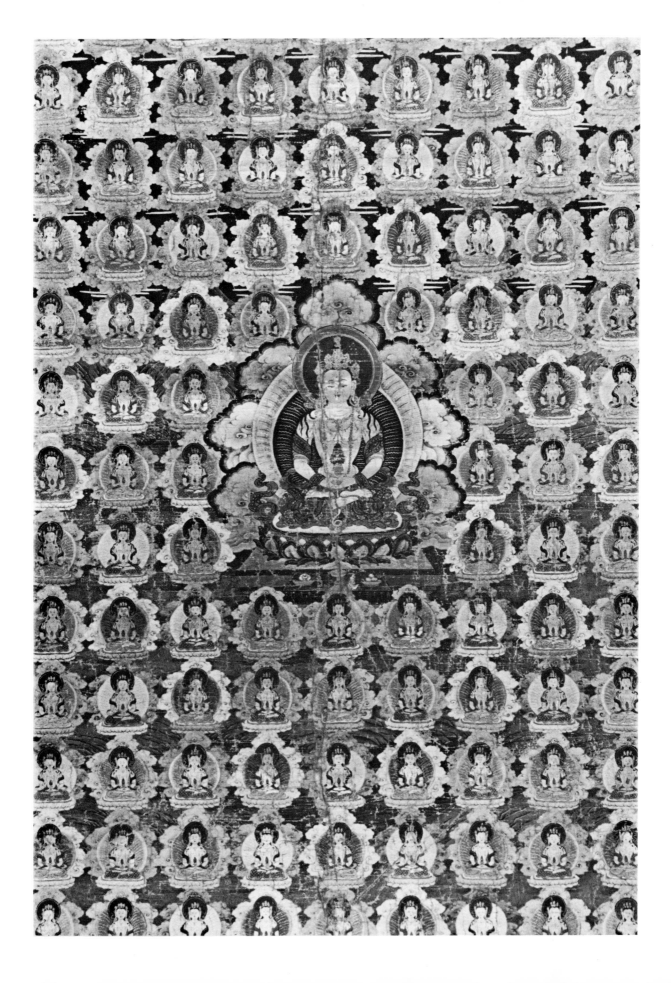

9 CAKRASAMVARA
18th century, Central Tibet

One of the main Yidams of the New Translation (Sarma) tradition,
Cakrasaṁvara is especially revered by the Gelug and the Kagyu
schools. Cakrasaṁvara's Himalayan home on the summit of Mt.
Kailāsa coincides with Mt. Meru, the center of the Universe.
Kailāsa with its surrounding area is considered one of the most
sacred places of pilgrimage in Western Tibet. Milarepa, whose
life exemplifies the superiority of Buddhism over Bon, the
earlier religion of Tibet, spent much time there with his
disciples. Above Cakrasaṁvara is a Dalai Lama. Below him
rides the world-protector Vaiśravaṇa.

36

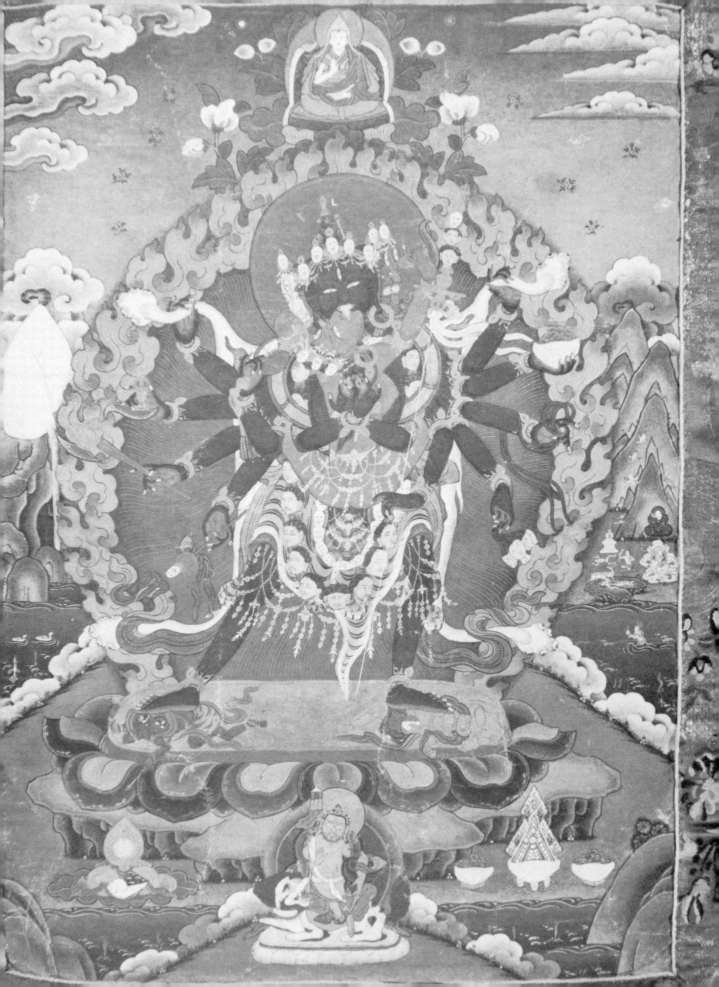

10 GUHYASAMĀJA
18th century, Mongolia

Guhyasamāja is the central deity and main subject of the Guhyasamāja Tantra, one of the principal Tantras studied and practiced by the Mahāsiddhas, the Buddhist yogins of India who flourished during the eighth to twelfth centuries. The great siddhas attained realization and special powers (siddhi) by following the Vajrayāna path which regards all forms of experience as opportunities for enlightenment.

At the upper left is Dorje Chang, the Ādi Buddha of the Gelug, Sakya, and Kagyu schools. Clockwise from the top center are Amitāyus, Buddha of Boundless Life, and black and white forms of the Dharmapāla Mahākāla.

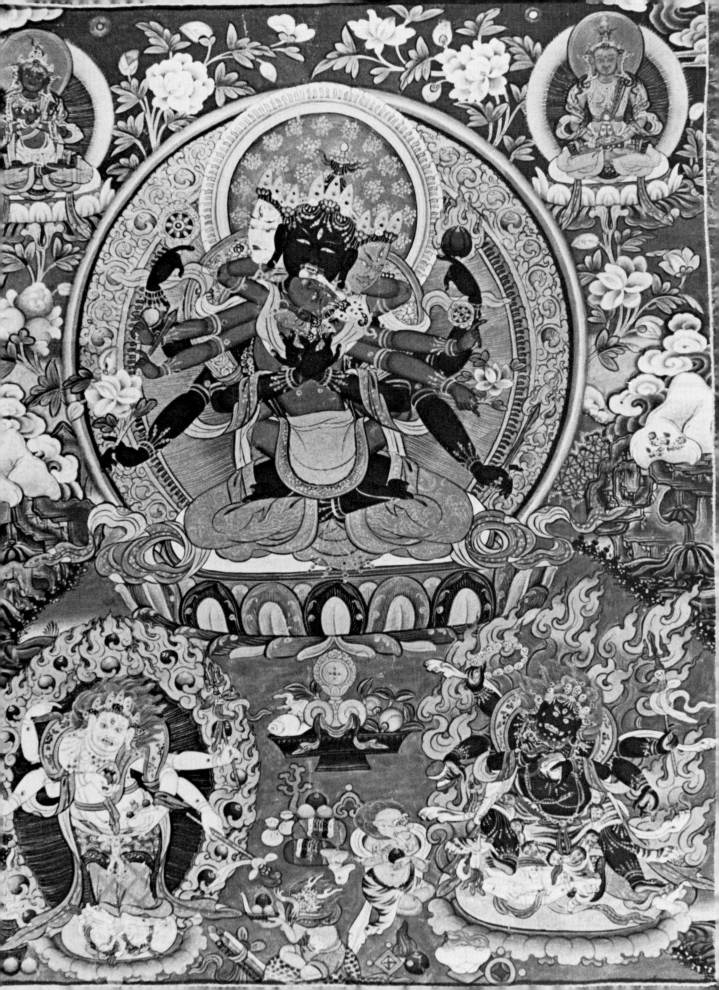

11 YAMĀNTAKA
18th century, Central Tibet

Yamāntaka, wrathful form of Mañjuśrī, represents wisdom
that subdues all obstacles and transforms understanding of death.
In Vajrayāna, death is seen as a change from a seemingly stable
existence to an unstable one. If one truly understands that each
passing moment represents the death of the past moment and the
birth of the next one, it is possible to penetrate confusion and
fear, and weaken death's grasp on the heart and mind.

Surrounded by flames, Yamāntaka treads on prostrate forms
that embody obstacles to enlightenment. Overhead, from left
to right, are the Panchen Rinpoche, White Tārā, the great
scholar Rolpe Dorje, Uṣṇīṣavijayā, and the four-armed
representation of the Great Bodhisattva Avalokiteśvara,
embodiment of supreme compassion.

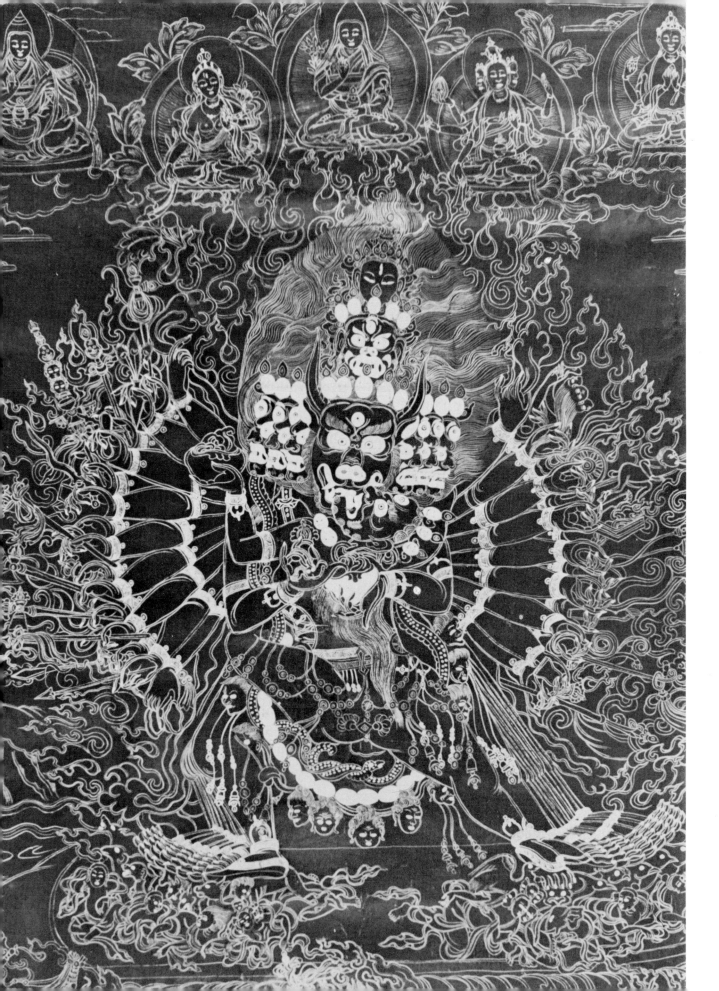

12 VAJRAPĀṆI
19th century, Central Tibet

As protector of the Mahāyāna teachings and unfolder of the
Tantras, the Bodhisattva Vajrapāṇi occupies an important position
in Vajrayāna Buddhism. Directly above him is Padmasambhava, with
Vimalamitra and Amitābha on the left and King Trisong Detsan
and White Tārā on the right. Below Vajrapāṇi, clockwise from
lower right, are Avalokiteśvara, Bodhisattva of Great Compassion;
a chorten, or stupa, representing the heart and mind of the
Buddha; Vajrasattva, embodiment of immutable purification; and
Mañjuśrī, the Bodhisattva of Omniscient Wisdom. This thanka is
probably a Nyingma work from or around the Mindroling Monastery
in Central Tibet.

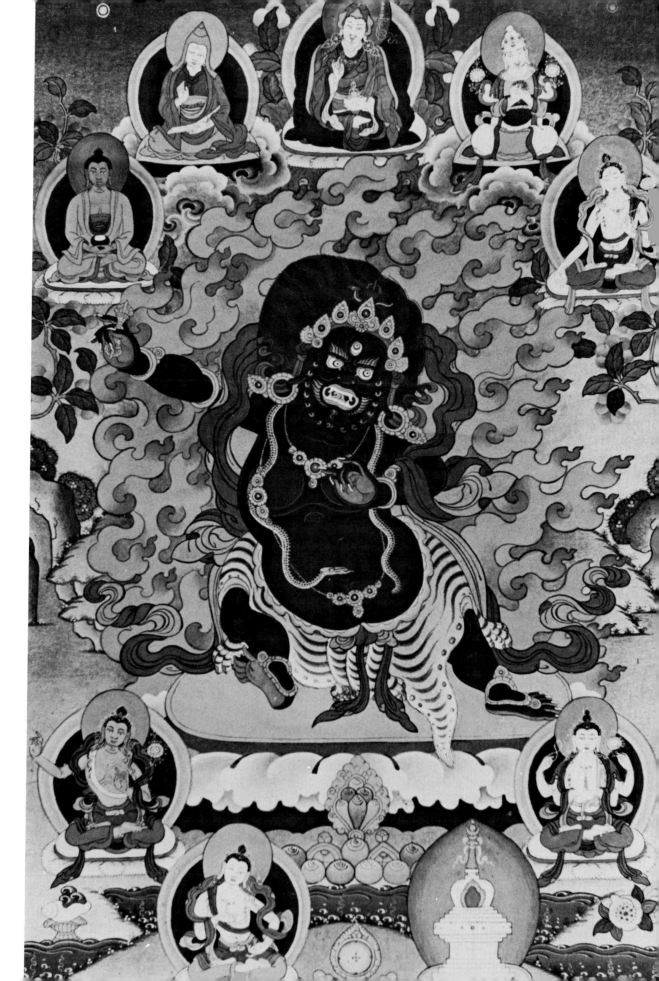

13 YAMĀNTAKA
18th century, Mongolia

Yamāntaka is the wrathful form of the Great Bodhisattva
Mañjuśrī, whose visage appears on the uppermost of
Yamāntaka's many heads. At the upper left is Tsongkhapa
holding lotuses that support a Dharma text on his left and
Mañjuśrī's flaming sword on his right. The figure at upper
right is probably Jetsun Tragpa Gyaltsen, one of the five great
Sakyapa Lamas and an incarnation of Padmasambhava. Directly
below Yamāntaka is an offering to the five senses, represented
by five animal faces. Yamarāja, Lord of Death, dances on a
bull at lower right. At lower left, seated on a snow lion, is the
World-Protector Vaiśravaṇa, bearing a victory banner in his
right hand and holding a jewel-spitting mongoose in his left hand.

44

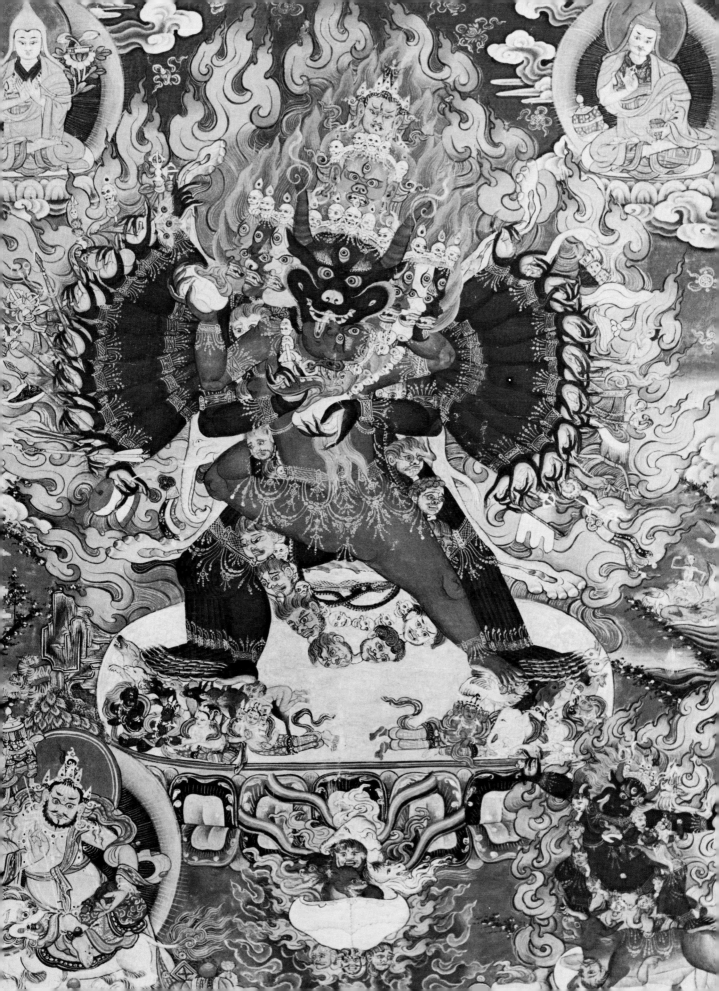

14 YAMĀNTAKA
18th century, Central Tibet

The sādhana of the powerful Yidam Yamāntaka, conqueror of Yama,
Lord of Death, was emphasized and disseminated by Tsongkhapa,
whose lineages are continued in the Gelugpa tradition. In this
thanka Yamāntaka embraces his feminine counterpart; both tread
upon figures representing sources of human suffering. Tsongkhapa
is seated above Yamāntaka's flame-surrounded form. Below is
Yama, mounted on a bull.

In the Gelugpa tradition, initiation into the Tantras was
possible only after a long period of studying the Sutras and
their commentaries. Then a monk could continue his education
at one of the tantric colleges established in the large Gelug
monasteries. The most famous of these colleges was the Gyudto,
located in the Jokhang, an ancient temple in Lhasa.

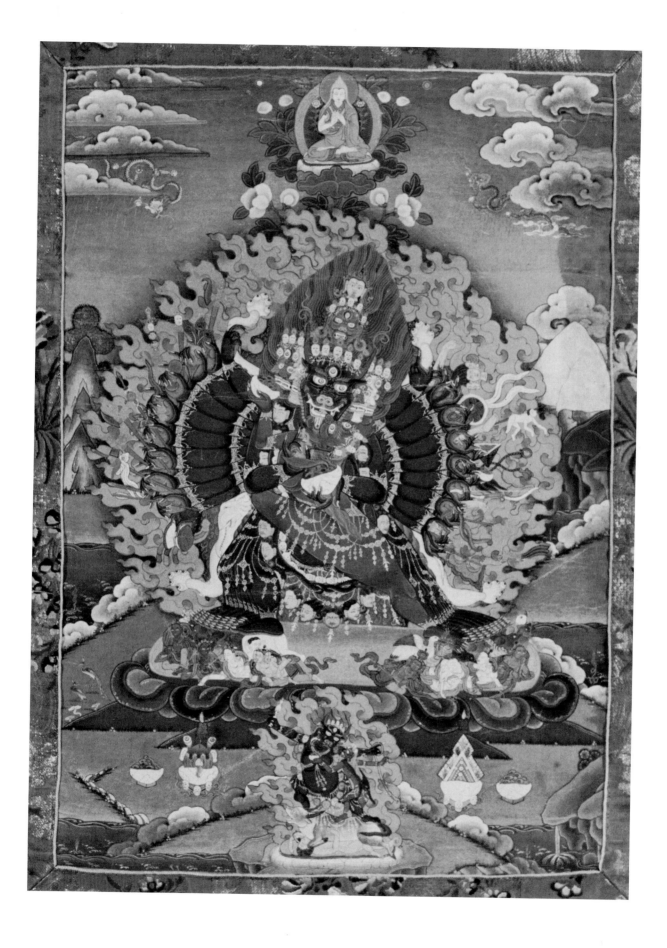

15 GURU PADMASAMBHAVA
19th century, Kham

This thanka portrays the deities and Lamas of the Nying Tig
lineage preserved in the Nyingma tradition. The Great Guru
Padmasambhava is seated at the center, encircled by a rainbow of
light. Directly above Padmasambhava is Avalokiteśvara, with
Amitābha seated at the thanka's top center. Jigmed Lingpa,
shown at the far upper left, was a reincarnation of Longchenpa
and one of the most outstanding Lamas of the 18th century. At the
far upper right is Jamyang Khentse Wangpo, Jigmed Lingpa's
bodily incarnation and the initiator of the Rimed movement.
Rimed is a nonsectarian approach to Dharma practice that took
form in the 19th century. It advocated the impartial study of the
teachings of all four major schools of Tibetan Buddhism.

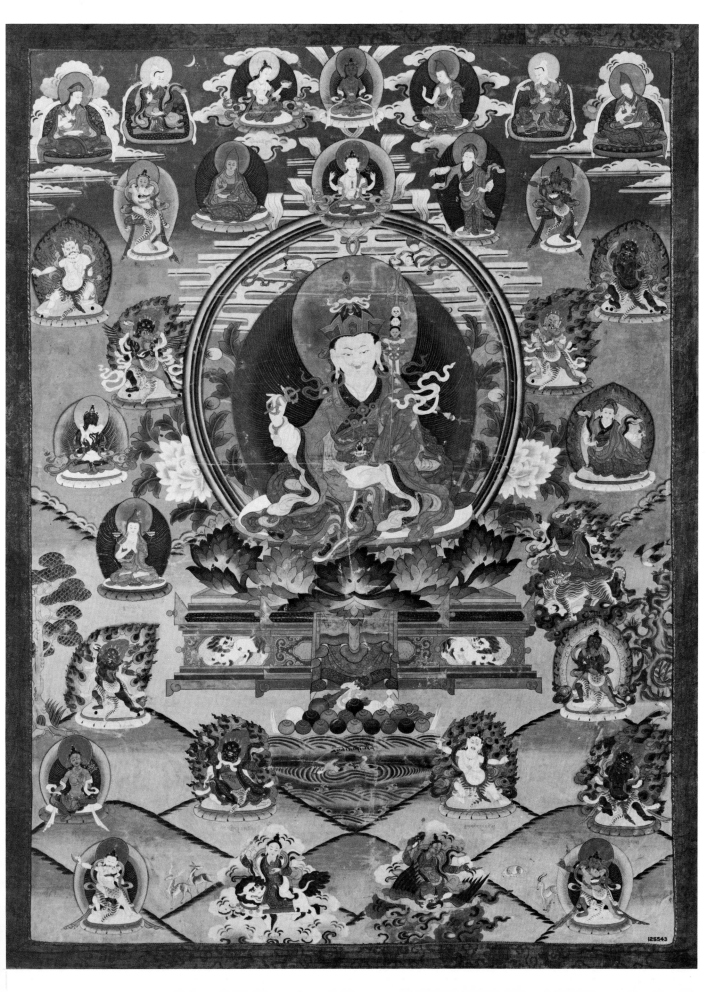

16 GURU PADMASAMBHAVA
18th century, Batang Monastery, Kham

This beautiful thanka depicts the coming of the Great Guru Padmasambhava to Tibet, where he transmitted the powerful teachings of the esoteric Tantras and laid the foundation for their continued transmission. Padmasambhava, the root Guru of the Nyingma tradition, is seated in his paradise Ngayab Pema, surrounded by scenes depicting his activities in Tibet. Manifesting in peaceful or wrathful forms, the Great Guru subdued the demons obstructing the Dharma and established centers for practice and realization. At lower left, Padmasambhava gives teachings on the Bardo and the mandalas of the peaceful and wrathful deities. At lower left, the Great Guru imparts his blessings to his Tibetan disciples.

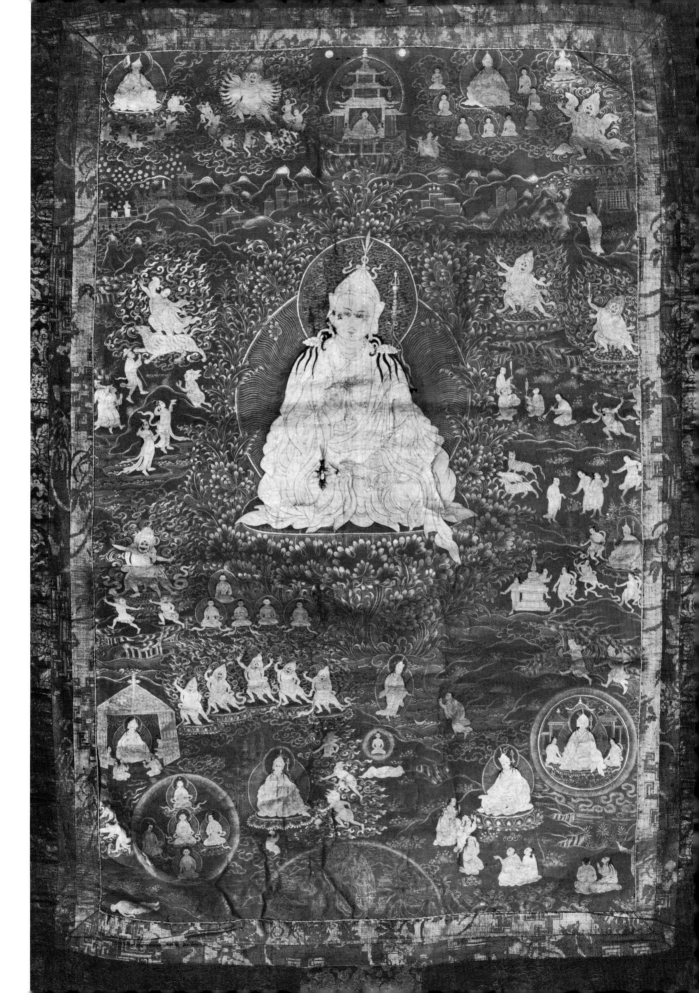

17 PADMASAMBHAVA AND THE EIGHT MANIFESTATIONS
18th century, Western Tibet

Seated on a lotus, Padmasambhava holds the khaṭvāṅga, the trident-topped staff bearing three human heads. In his upraised right hand he holds a dorje, and in his left hand a skull-cup filled with ambrosia. The Great Guru is attended by two of his foremost women disciples, shown offering him ambrosia-filled skull-cups; on his right is Princess Mandāravā, and on his left is Yeshe Tshogyal, one of Tibet's most outstanding masters.

Surrounding Padmasambhava are his eight major manifestations, each relating to an aspect of the Great Guru. Directly above him is Urgyan Dorje Chang, Padmasambhava as the primordial Buddha. At top right is Guru Loden Chogsed, the Guru Endowed with Understanding the Highest Wishes. Beneath him is Padma Gyalpo, the Lotus-king Guru. Dorje Drolod, enveloped in flames of indomitable energy, rides on a tiger at the lower right. Senge Dradog, the wrathful form in which Padmasambhava manifested to subdue Tibet's local deities, appears directly below the central figure. At lower left is Nyima Odzer, the Great Guru as master of Yogis. Above, upper left, is the scholar-monk Guru Padmasambhava, and above him is Shakya Senge, "Lion of the Śākyas," the clan that Lord Buddha was born into for his final existence in the world. Shakya Senge is shown making the earth-touching gesture associated with the enlightenment of a Buddha.

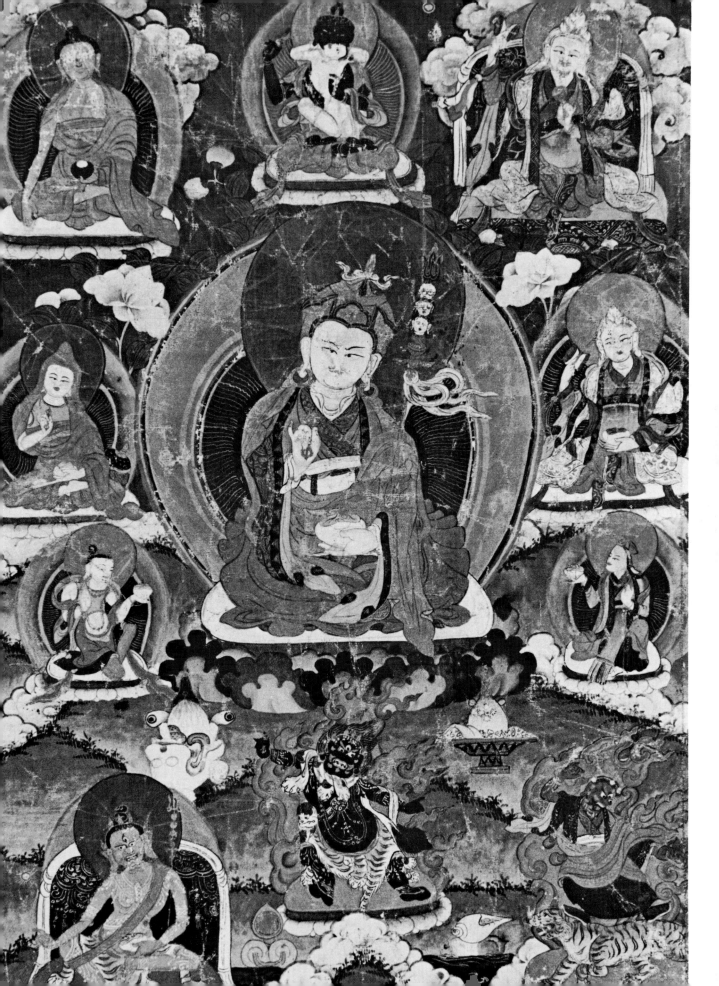

18 GREEN TĀRĀ
Thanka detail, 18th century, Kham

Here Tārā is depicted saving a devotee from a demon, out of
view in this detail from a larger painting. This standing form
of Tārā is relatively rare, since Tārā is usually depicted seated
on a lotus, ready to descend to aid suffering beings. This painting
reflects some Chinese stylistic elements. Tārā's traditional lotus
seat is replaced by a dias of leaves, reminiscent of the T'ang Dynasty
manner of portraying Buddhist deities. The flowing lines of the figure
and robes, as well as the lack of full Sambhogakāya ornamentation,
also mirror the Chinese style.

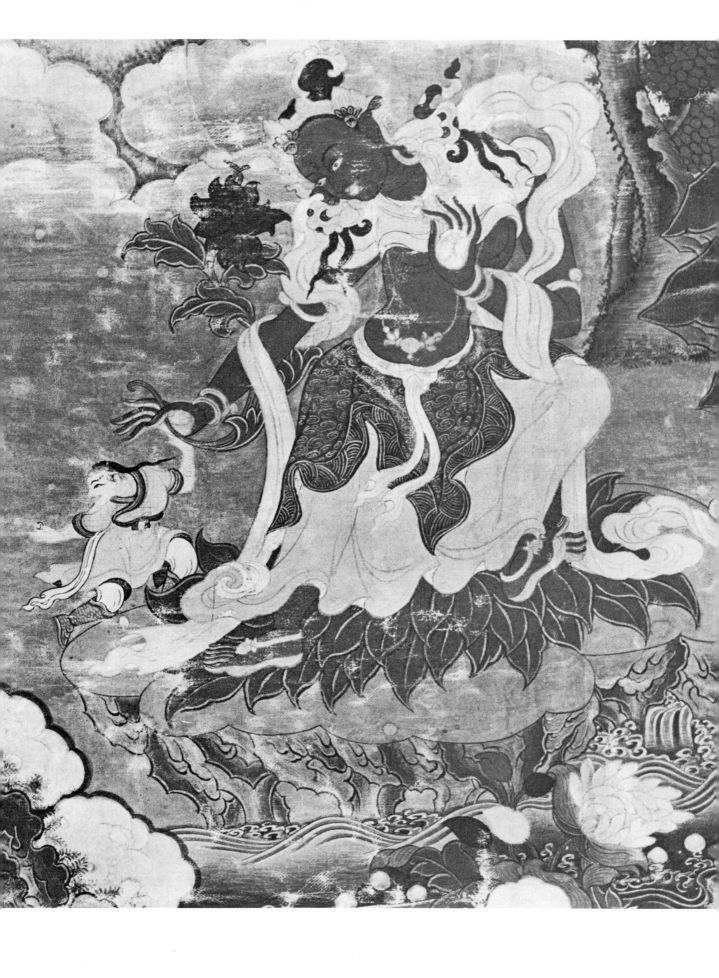

19a. Detail of the Bodhisattva descending into the womb of Queen Māyā.

19 THE BODHISATTVA'S LAST BIRTH
18th century, Derge

Painted from a set of blocks carved in Derge in the 17th century,
this thanka illustrates the acts surrounding the birth of Prince
Gautama, who will, upon his enlightenment, become the Buddha
Śākyamuni. At the upper left the Bodhisattva leaves Tuṣita heaven
in the form of a white elephant; at lower right he enters into the womb
of his mother Queen Māyā. Queen Māyā stands at the center. As she
grasps the branch of a tree, the child emerges from her right side
onto a cloth held by Indra, king of the gods. At lower left, the
newborn Bodhisattva takes seven steps. Annointed by heavenly
beings, he announces that this is his final rebirth.

56

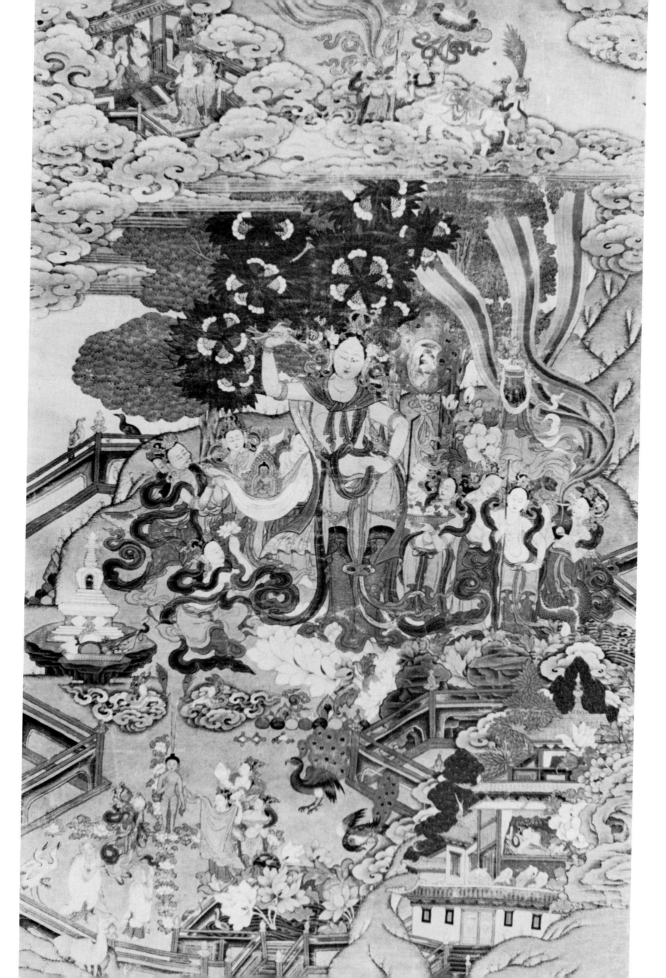

20 NĀRO KHACHODMA
18th century, Central Tibet

Nāro Khachodma, or Nāro the sky cleaver, is an emanation of
Vajra Yoginī. Propitiated by the great siddha Nāropa, famed
for completing the twelve great and twenty-four lesser trials
under his master, the Mahāsiddha Tilopa, Nāro Khachodma gave
Nāropa teachings known as the Six Yogas. Nāropa transmitted
them to his outstanding Tibetan disciple Marpa, who brought their
lineages to Tibet. In turn, Marpa transmitted the Six Yogas to
Milarepa and other disciples. In her manifestation as Dorje
Phagmo, Vajra Yoginī protects the Dharma in Tibet. For centuries
she has successively reincarnated as the Abbess of Samding
Monastery, located in Central Tibet.

Nāro Khachodma, wearing bone ornaments and a garland of human
skulls, holds a chopping knife in her right hand and a skull-cup
in her right. Surrounded by flames, she treads on figures
representing obstacles to the Dharma. Above her is the 7th Dalai
Lama. Below are the dancing skeletons known as the Citipati.

58

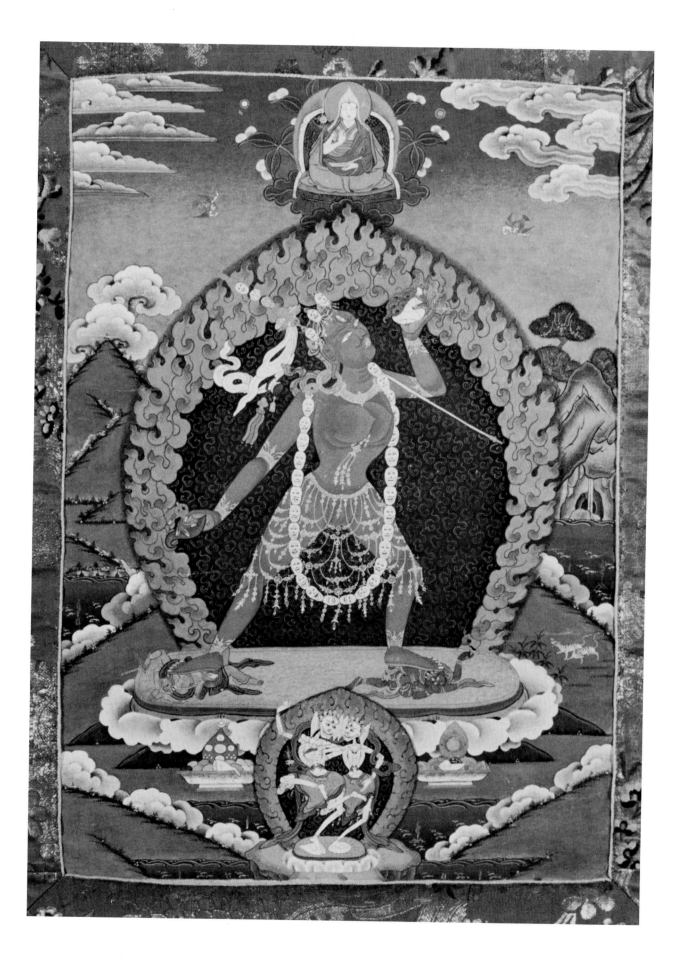

21 KURUKULLĀ
18th century, Central Tibet

Kurukullā, a wrathful manifestation of Tārā, is considered
both a Yidam and a Dharmapāla, and is represented in many
forms. Dark red in color, Kurukullā as depicted here has three
eyes and four arms. Clad in a tiger skin, she wears bone
ornaments, a skull crown, and a garland of human heads. In her
upper hands she brandishes a fully-drawn bow strung with a
blooming lotus-stalk arrow. Her lower hands hold a flowered
elephant-goad and a red lotus. Surrounded by flames, she dances
on a prostrate human form, overcoming sources of human suffering.
The seventh Dalai Lama is seated above. Below, the protectress
Palden Lhamo rides guard upon her mule.

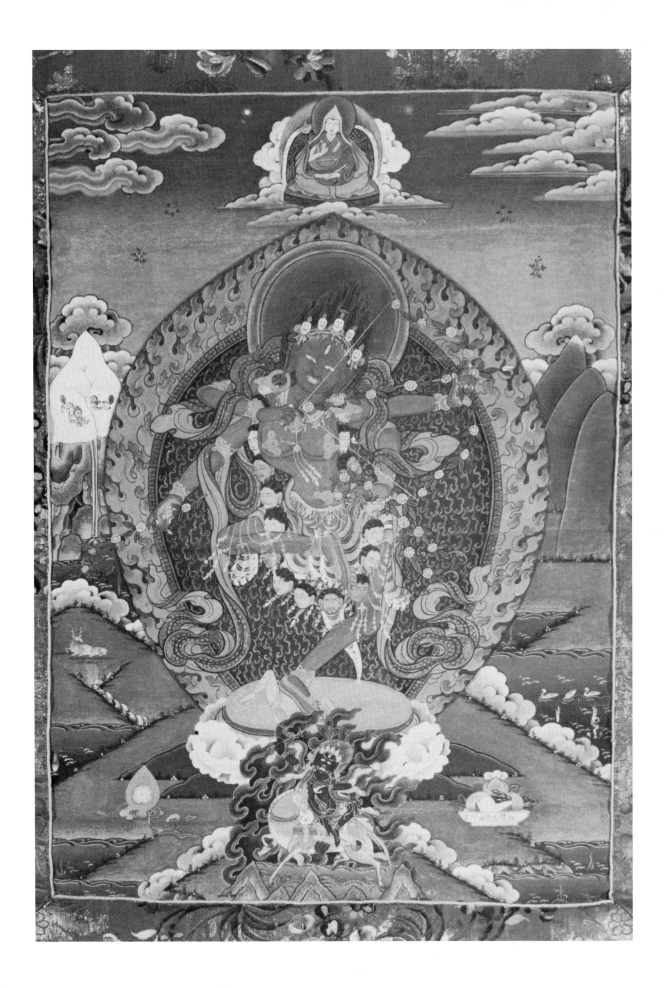

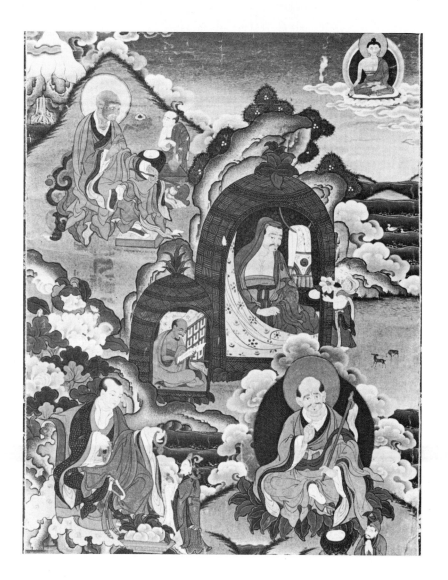

22 FOUR ARHATS
19th century, Central Tibet

This thanka depicts four of the Sixteen Great Arhats, disciples
of the Lord Buddha who vowed to remain in the world and protect
the Sangha until the appearance of the future Buddha Maitreya.
Clockwise from the top left are Aṅgaja, Ajita, Vanavāsin, and
Kālika. Near the center, in the smaller of the two grass huts,
is the Arhat's faithful attendant Dharmatāla. The Dhyāni
Buddha Ratnasambhava is seated on a cloud-borne lotus in the
upper right corner.

Opposite page: Detail of Kālika being presented with an offering.

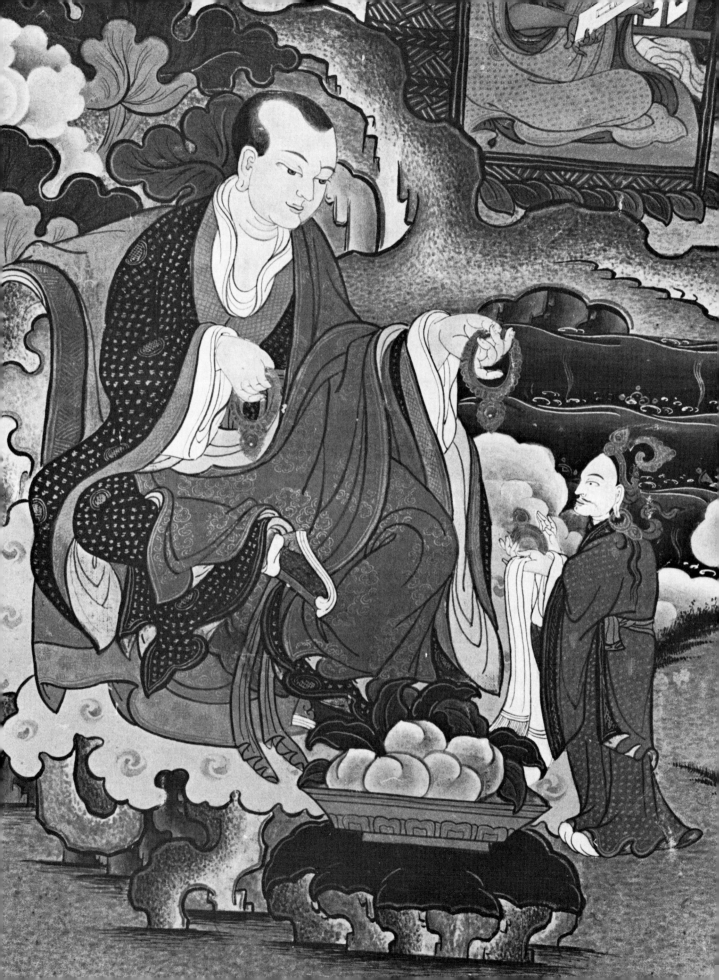

23 ABHAYĀKARAGUPTA
Early 20th century, Central Tibet

The 11th- to 12th-century master Abhayākaragupta, abbot of
the university of Vikramaśīla and one of the last of India's
great Buddhist siddhas and scholars, foresaw the decline of the
Dharma in India. Intent on preserving the Dharma for future
generations, Abhayākaragupta collected the lineages and texts
of all Dharma traditions and prepared a large number of commen-
taries. Together with his Tibetan disciples, he translated more
than 130 texts into Tibetan, most of which were preserved in the
Tibetan Buddhist Canon.

In this finely woven thanka, Abhayākaragupta is depicted as a
siddha-scholar. Entwined around his body is a snake, expressing
his power over the Nāgas and his ability to counteract the
poison of snake-bites. Directly above him is a siddha, probably
his teacher Ratnākaragupta. In the upper left corner is the
Ḍākinī Vajrayoginī, who predicted that he would receive
the siddhi of fore-knowledge in the bardo, the intermediate
state between death and rebirth. Beneath Abhayākaragupta is
Mahākāla, fearsome protector of the Dharma. At left, a monk
holds open the door for naked figures to emerge from below,
indicating that Abhayākaragupta liberated many beings from the
hell-realms.

One of a set depicting the incarnation lineage of the Panchen
Rinpoche, this thanka was printed from blocks cut at Narthang
Monastery in Central Tibet during the 17th century. Images on the
blocks were transferred to cloth, which was then painted to form
thankas. His Holiness the 13th Dalai Lama took a set of these
thankas to Peking around the turn of the 20th century. There
weavers connected to the Manchu court made woven copies of them
on their looms. This thanka is a rare example of these exquisitely
woven thankas.

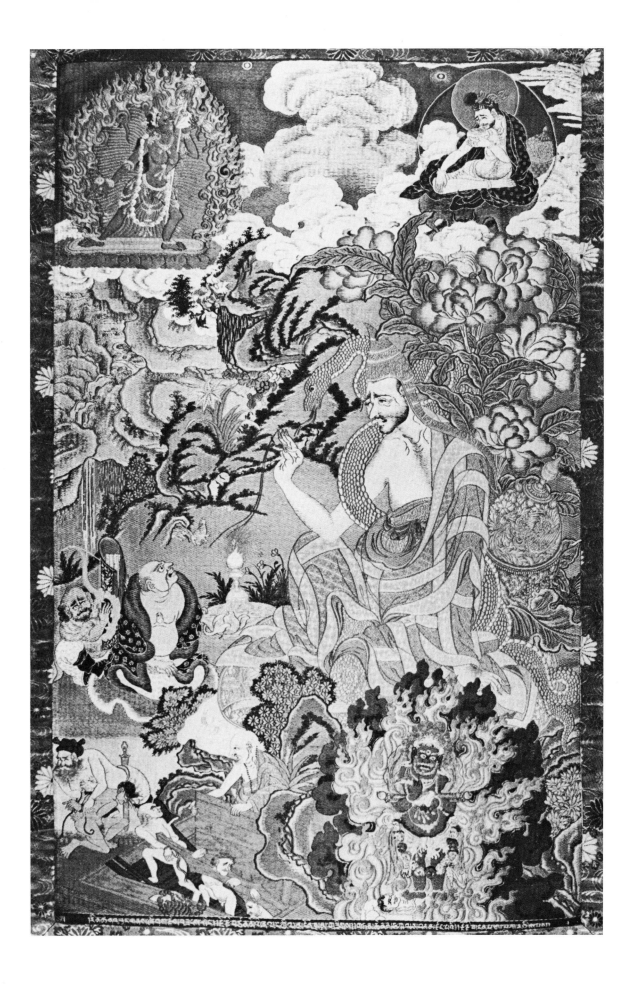

24 GREEN TĀRĀ
Early 19th century, Central Tibet

The Great Bodhisattvā Green Tārā, Tibet's special
patroness, is regarded as the spiritual friend of all sentient
beings. It is said that Tāra was born from a tear shed
by the Bodhisattva Avalokiteśvara upon seeing the plight of
living beings enmeshed in the pain-filled, deadening rounds of
samsāra. Tārā is invoked as a radiant lamp in the darkness
of unknowing, as the guide to realization amidst obstacles to
enlightenment, as a welcome companion at the time of death, and
as a refuge of light in the dark womb of rebirth.

In this thanka, Green Tārā is enthroned in her paradise,
ready to descend to relieve the sufferings of sentient beings.
Holding a lotus, symbol of compassionate love, in her left hand,
she bestows blessings with her right hand, held in the varada
mudrā, the gesture of offering mercy.

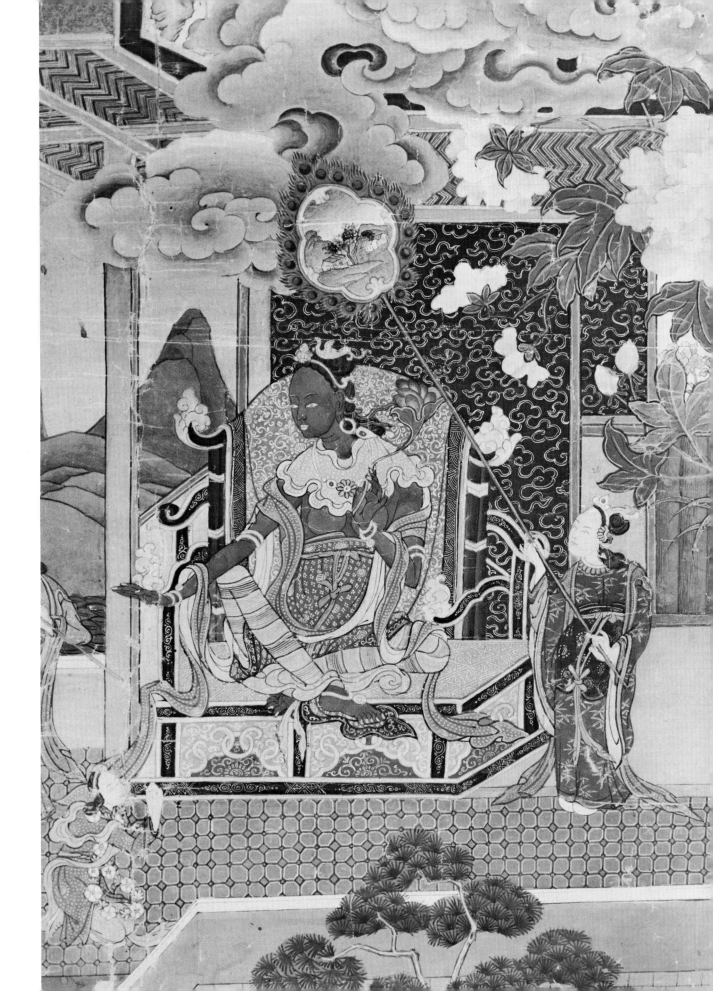

From the great ocean vapors rise.
Reaching the vast sky
they form great clouds.
A causal law governs the transformations
 of the elements.

In midsummer, rainbows appear above the plain,
gently resting upon the hills.
Of the plains and the mountains,
the rainbow is the beauty and adornment.

I, the Yogi who desires to remain in solitutde,
meditate on the Voidness of Mind.
Awed by the power of my concentration,
you jealous demons are forced to practice magic.
Of the yogi, demonic conjurations
are the beauty and adornment.

Milarepa

25 MILAREPA
20th century, Padma Ling Monastery

Considered the Lord of Yogins, Milarepa is well-known for the
depth of his realization, the power of his devotion, and the
beauty of his poetical songs. It is said he possessed acute powers of
hearing; thus he is usually depicted cupping his right hand to his ear,
continually attentive to the needs of sentient beings. The antelope skin
he sits upon denotes his gentleness and compassion.

 A renunciate known for wearing a simple white cloth and
subsisting on nettles, Milarepa inspired and instructed many
disciples. Foremost among them was Gampopa, from
whom all the Kagyu schools are descended.

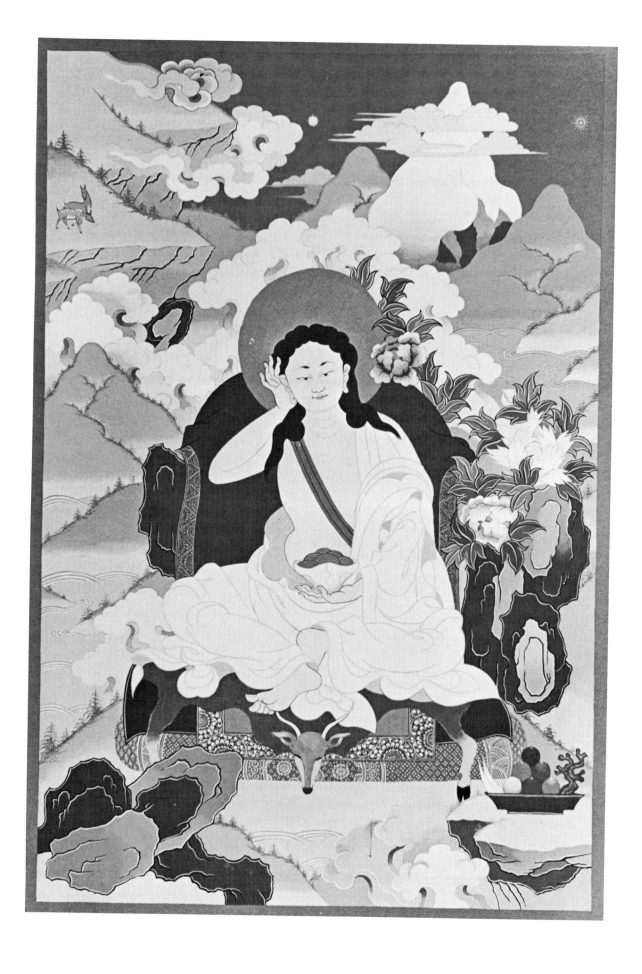

26 HO SHANG AND THE GUARDIAN KINGS
20th century, Central Tibet

Taken from a set of blocks representing the disciples of Lord
Buddha and the Four Guardian Kings, this thanka depicts the
Dharma patron Ho Shang (above), surrounded by children who
respond joyfully to his presence. At lower left is Virūḍhaka,
Guardian King of the South, surrounded by flames; beside
him is Dhṛtarāṣṭra, Guardian King of the East, ruler of the
Gandharvas, or heavenly musicians. Together with Vaiśravaṇa
and Virūpākṣa, Guardian Kings of the North and West, they
comprise the Four Lokapālas, the protectors of the Dharma who
preside over the four directions.

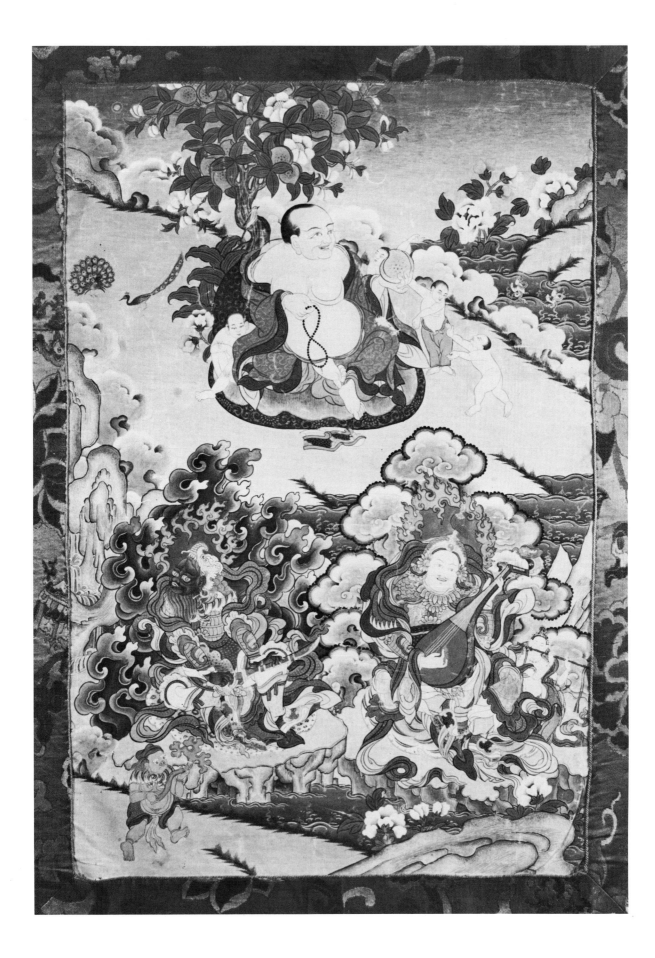

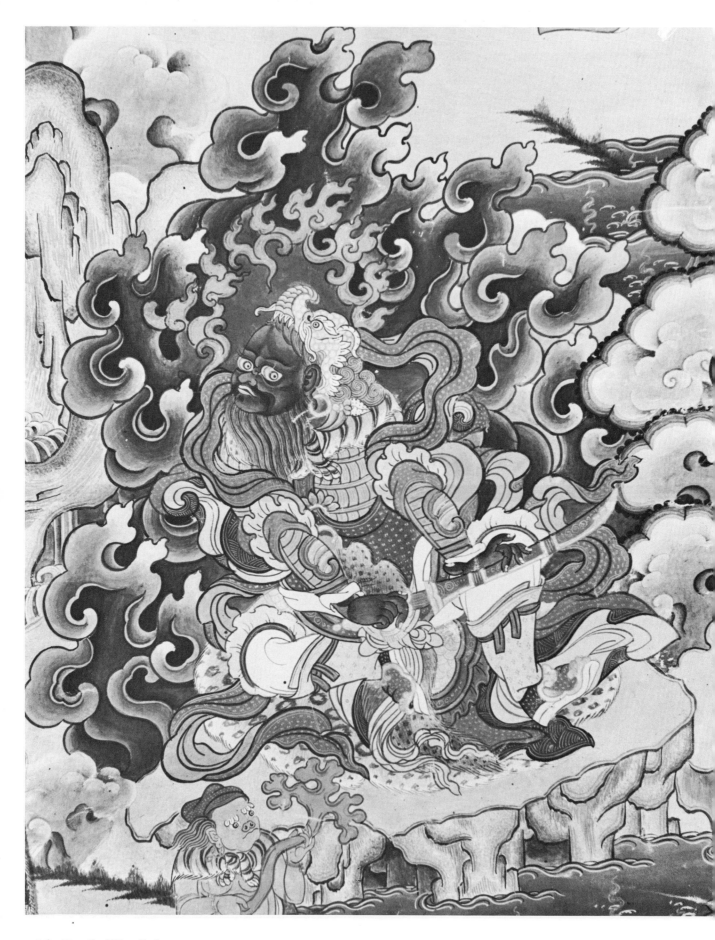

26a. Detail of Virūḍhaka

26b. Detail of Dhṛtarāṣtra

27 MANDALA OF USNĪSAVIJAYĀ
18th century, Kham Province

Uṣṇīṣavijayā is an emanation of the Uṣṇīṣa, the
victorious aspect of the Mind of the Buddha. This aspect
cannot be conquered, since it is not concerned with whether
positive or negative forces are brought to bear in a particular
situation. Enlightened Mind engages the situation directly,
without judgments of good or bad. Thus any movement is a
response to the situation rather than a reaction to or against
it. Since Uṣṇīṣavijayā is an aspect of the Mind of the
Buddha, her six-armed form often appears in the center of the
Choden which symbolizes the Mind.

74

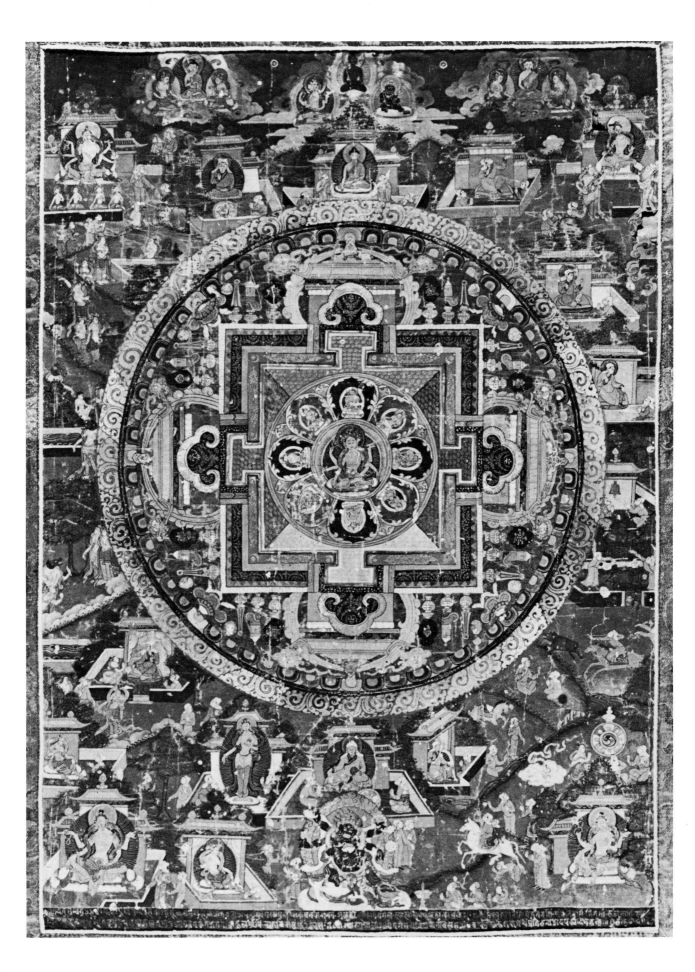

28 DAṆḌA MAHĀKĀLA
Early 19th century, Tsang Province

Surrounded by flames, the Dharmapāla Daṇḍa Mahākāla
carries a staff capped at both ends by flaming jewels; in his left
hand he holds a skull-cup, and in his right a chopping knife that
severs attachments. His waist is encircled by a snake, and he
wears the ornaments of the fierce representations: a crown of
five skulls, necklaces of bone, and a garland of human heads.

Mahākāla was once an Indian siddha who vowed to protect the
Dharma through the exercise of skillful means. Thus Mahākāla
manifests in many forms according to the needs of a situation.
Here Mahākāla is accompanied by seven of his wrathful mani-
festations. Above, in the upper left corner, is Hevajra with his
consort. In the upper right corner is Tromo Metseg.

76

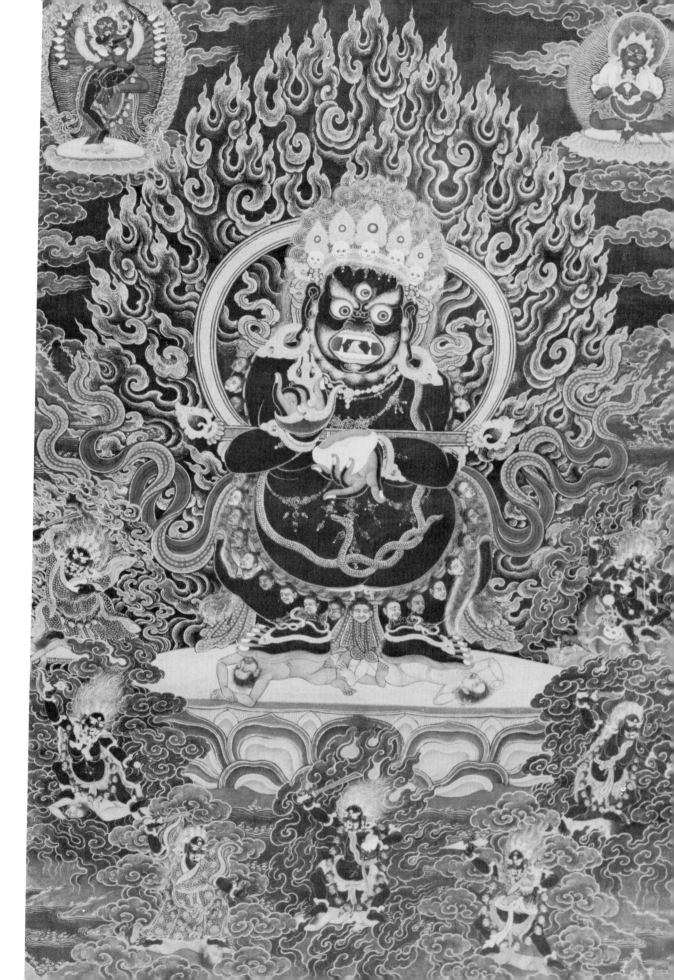

29 VAIŚRAVAŅA
17th century, Nepal

Vaiśravaṇa, ruler of all the Yakṣas, is the Guardian King who
protects the Dharma in the North. Vaiśravaṇa is often referred
to as Kubera, Lord of Wealth. He holds a jewel-spitting mongoose
in his left hand, indicating his responsiveness to those who invoke
his aid.

This thanka is a fine example of Nepalese art, easily identifiable
by the decorative motif surrounding the central figure and the Lantsa
characters around the border. When Buddhism came to Tibet, many
artisans from Nepal and Kashmir migrated there. Their work influ-
enced the development of painting styles and enriched a vital
artistic tradition that has persisted to modern times.

30 CITIPATI
Thanka detail, 19th century, Central Tibet

The Citipati appear at the bottom of many thankas. Reminders of
the folly inherent in dualistic thinking, they graphically depict
the death-like quality of samsaric views and prompt the viewer to
seek liberation from all forms of suffering. In the background,
carnivorous animals search a cemetery for corpses, a graphic
depiction of the end of all existence. The Citipati also appear
in traditional Tibetan religious dances.

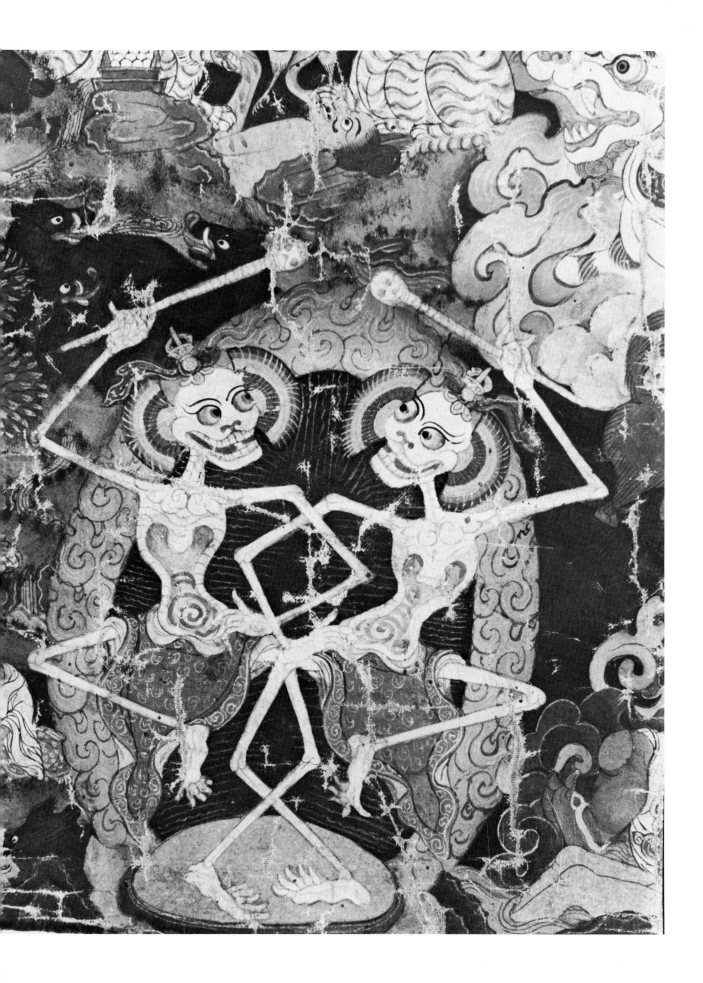

31 ŚĀKYAMUNI BUDDHA
19th century, Tsang Province

Seated on a double-petalled lotus, Śākyamuni Buddha reposes
in deep samādhi, holding a mendicant's bowl in his left hand. His
right hand is held in the earth-touching mudrā, the gesture by
which he subdued Māra, Lord of Illusion, and signalled the
immanence of enlightenment.

Vowing not to rise until enlightenment was obtained, the Blessed
One took his seat under the Bodhi Tree at Bodh Gayā. Māra,
perceiving his power threatened, sought to sway the great sage
from his purpose. He sent his lovely daughters to tempt the
Bodhisattva with their beauty and appeals to worldly power,
wealth, and prestige. Seeing that the Bodhisattva's gaze
turned his daughters to ugly hags, Māra dispatched his demon
horde to destroy the sage completely. But the demon's arrows
turned to flowers as they touched him. Serene and unmoved,
Śākyamuni touched the ground, calling upon the earth to bear
witness to his lifetimes of selfless actions and dedication to
the welfare of all sentient beings. Vanquished, Māra fled.
That night, absorbed in deep samādhi, Śākyamuni attained
complete, perfect enlightenment.

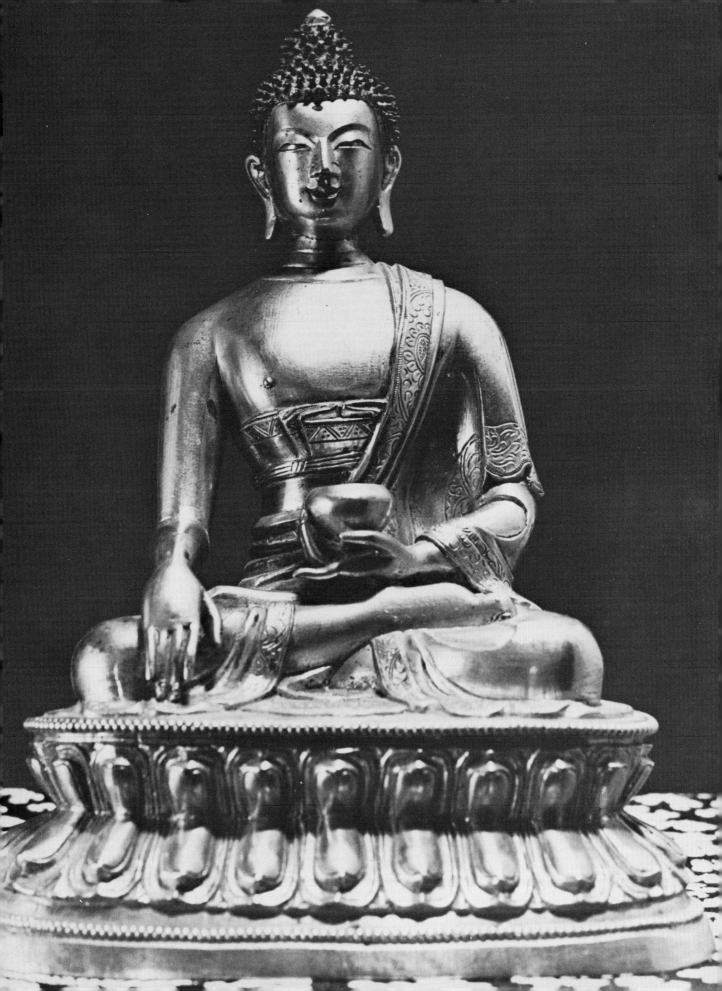

32 TATHĀGATA RATNA NĀGEŚVARARĀJA
15th century

The Tathāgata Ratna Nāgeśvara, lord of the Nāgas,
is one of the thirty-five Buddhas of Confession. Seated in deep
samādhi, Nāgeśvararāja holds his hands palms together at
heart level, with the forefingers touching.

 Also known as Buddhas of Forgiveness, the Confession Buddhas
compassionately encourage mindfulness of thought, word, and deed,
our surest protection against self-destructive behavior. A critical
step in developing mindfulness is the confession of error, in
which one acknowledges undesirable conduct. Guidelines that
support the growth of insight are given in the Prātimokṣa,
the core of the Buddha's Vinaya teachings. Every full and new
moon, ordained monks and nuns convene to chant this text, reflect
on infractions committed, and reaffirm their resolve to govern
body, speech, and mind with greater mindfulness and wisdom.

33 SIṀHANĀDA AVALOKITEŚVARA
18th century, Peking

Siṁhanāda Avalokiteśvara embodies the piercing insight
aspect of the Buddha's limitless compassion. He possesses the
power to proclaim the Dharma with the "roar of a lion"
(siṁhanāda), which penetrates obscurations and resonates
throughout the whole of one's being. The enlightened compassion
manifested by Avalokiteśvara is guided by a clear awareness of
the situation under which it arises. The activity of compassion
is guided by knowledge of skillful means. This knowledge promotes
a fearless quality, symbolized by the Great Bodhisattva mounted
on a lion. The lion's mouth is open, suggesting the fearless
proclamation of the Dharma. This proclamation is also
all-victorious. Heard and taken to heart, it removes all
obstacles to insight.

34 HAYAGRĪVA
18th century, Kham Province

Known as the "horse-headed one," Hayagrīva represents one of
the deities of the Nyingma Gyudbum, or the Hundred Thousand
Tantras preserved in the Nyingma tradition. Within this
collection are found some of the most profound insights into the
nature of mind, being, and existence ever transmitted. The Tantras
of the Nyingma Gyudbum were translated into Tibetan during
the 8th century, when masters such as Guru Padmasambhava,
Vimalamitra, and Vairotsana Rakṣita were active in Tibet.

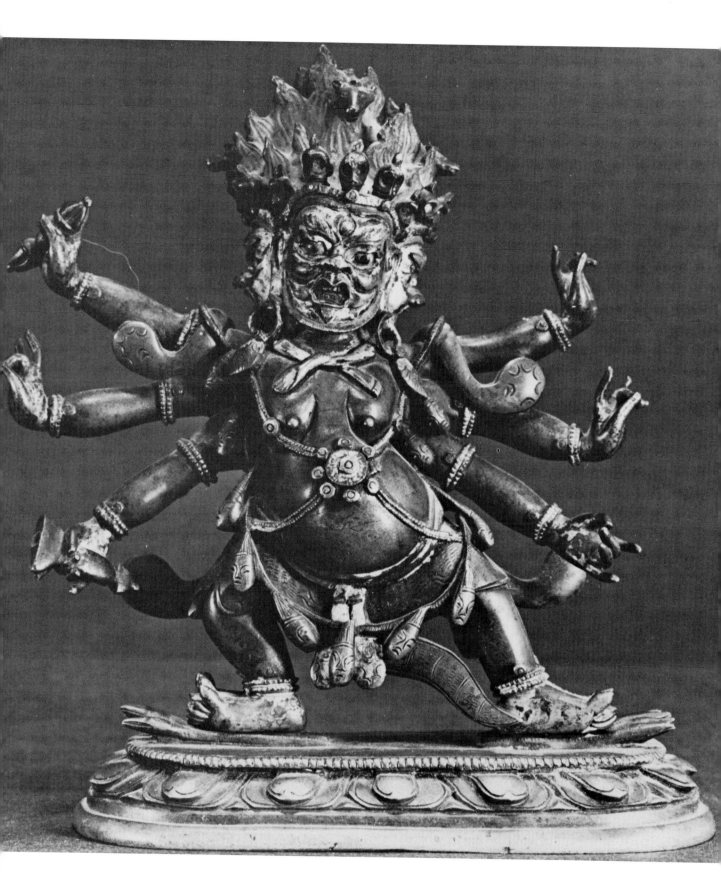

35 YAMARĀJA YAB-YUM
19th century, Central Tibet

This statue depicts Yamarāja, Lord of Death, accompanied by his
yum or wisdom-consort Yamī, riding upon a bull. This grouping
represents the outward aspect of death, that aspect generally
feared by the unenlightened. Yama, in the form of Dharmarāja,
judges the dead as they enter the Bardo. By looking into the
Mirror of Karma that reveals all past actions, he determines the
proper rebirth for each being that appears before him. His
decision determines in which of the six realms of existence the
person will be reborn.

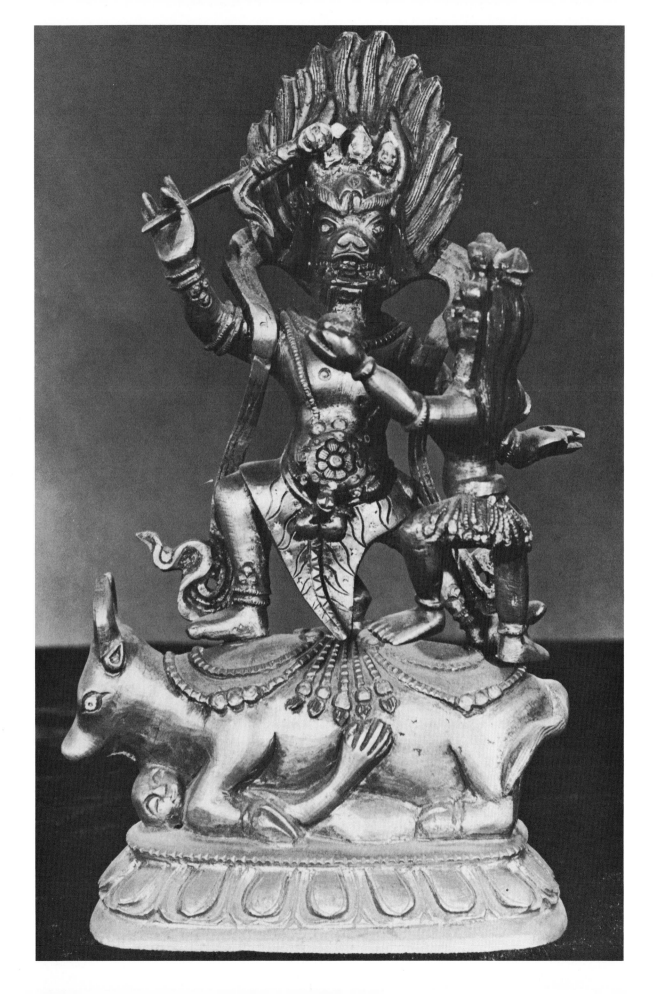

36 TSONGKHAPA
17th century, Central Tibet

The great master and scholar Tsongkhapa, also known as Lozang
Tragpa, is usually referred to as Je Rinpoche, or Precious Lord.
An incarnation of Mañjuśrī, he was born in Amdo in 1357,
and received instruction from lamas of all the traditions of his
day, including masters of the Nyingma, Kagyu, and Kadam
traditions. Although the Kadam school, founded centuries before
by the Indian master Atīśa, no longer existed as a distinct
entity, Atīśa's lineages lived on within the other traditions.
Through diligent study and practice, Tsongkhapa collected
these lineages. In 1409 he established Ganden Monastery east of
Lhasa, where a school known as the "new Kadampa," or Gelugpa
took form. Tsongkhapa emulated Atīśa's approach to a Dharma
education, favoring large monastic complexes, and emphasizing
Vinaya and philosophical studies.

A prolific writer, Tsongkhapa composed a great number of
texts, including the *Lam Rim Chenmo (The Great Stages of the
Path)* and the *Ngag Rim (The Stages of Mantra)*. These works
clarified the guiding principles of the Gelug tradition, and
provided the foundation for this school's study and practice.
In thankas, Gelugpa masters can be recognized by their yellow
hats, a feature that distinguishes them from teachers of the
older schools, who usually are depicted wearing red hats.

92

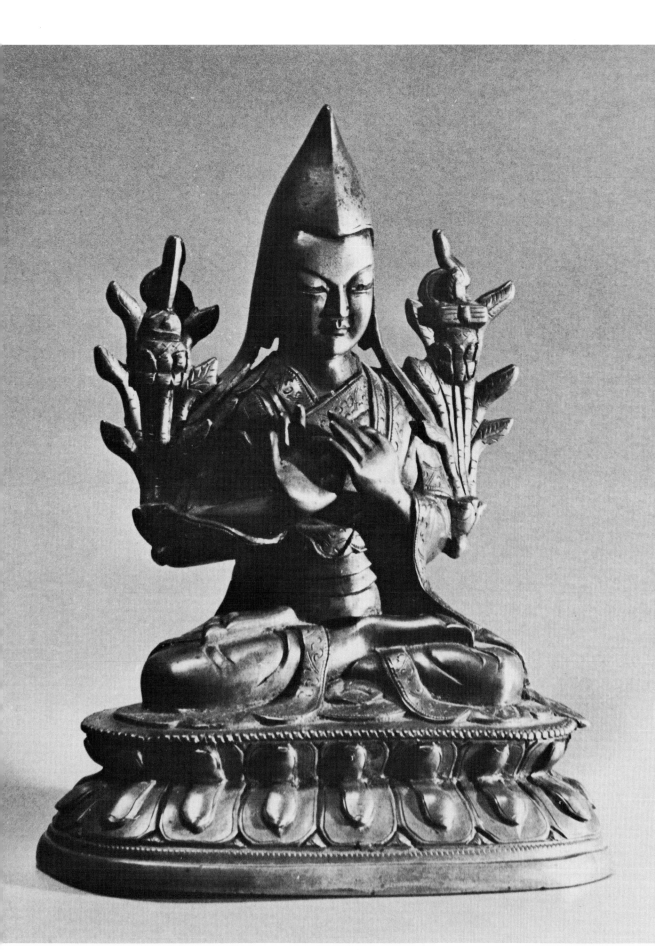